EVELYN CAMERON

Photographer on the Western Prairie

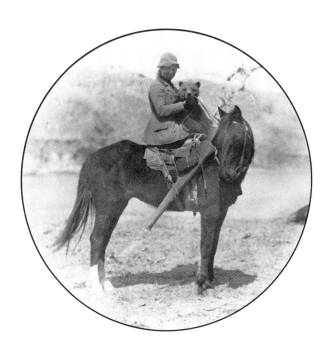

EVELYN CAMERON

Photographer on the Western Prairie

LORNA MILNE

2017
Mountain Press Publishing Company
Missoula, Montana

Photos used by permission from the Montana Historical
Society Research Center Photograph Archives.

Cover photo: Evelyn Cameron on her horse Trinket with her
camera in the case and tripod tied behind the saddle.

Title Page photo: Evelyn Cameron with one of the bear cubs they
captured and later sent to the London Zoo. Evelyn rode sidesaddle
back to camp with the shrieking cub in her lap.

Library of Congress Cataloging-in-Publication Data

Names: Milne, Lorna, 1957- author.
Title: Evelyn Cameron : photographer on the Western prairie / Lorna Milne.
Other titles: Photographer on the Western prairie
Description: Missoula, Montana : Mountain Press Publishing Company, [2017] |
 Includes bibliographical references and index.
Identifiers: LCCN 2017008885 | ISBN 9780878426751 (pbk. : alk. paper)
Subjects: LCSH: Cameron, Evelyn, 1868-1928. | Photographers—United
 States—Biography. | Women photographers—Montana—Biography.
Classification: LCC TR140.C26 M55 2017 | DDC 770.92 [B]—dc23
LC record available at https://lccn.loc.gov/2017008885

PRINTED IN THE UNITED STATES

MP Mountain Press
PUBLISHING COMPANY
P.O. Box 2399 · Missoula, MT 59806 · 406-728-1900
800-234-5308 · info@mtnpress.com
www.mountain-press.com

For Ty John Milne, who saw more than most
1964–2016

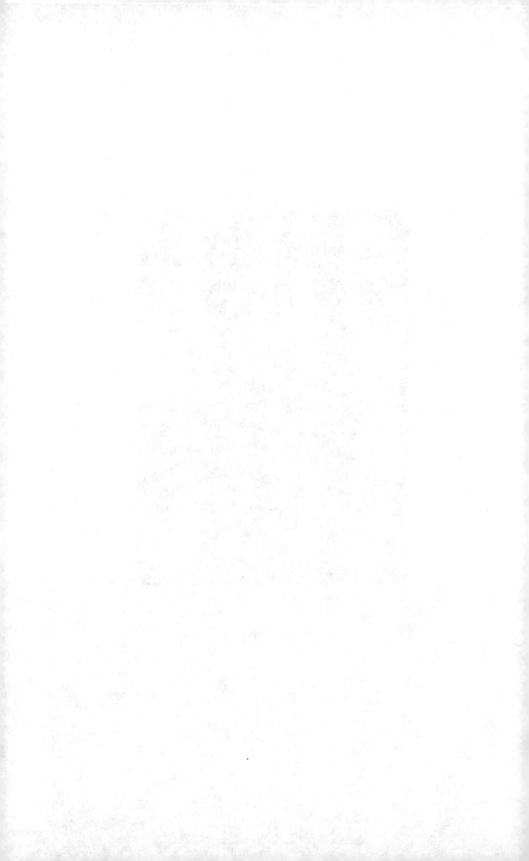

CONTENTS

PREFACE

Like many of Evelyn Cameron's admirers, I first came to know her through her photographs. Soon after moving back to Montana in 1988, I heard about a book coming out that included scenes of early European settlement in the eastern part of the state. The book, by Donna Lucey, was titled *Photographing Montana: The Life and Work of Evelyn Cameron*. I was raised in eastern Montana and felt sure I'd find photographs of people who had the same surnames as people I knew. But more, I hadn't seen many historical images of this region.

When I visited an exhibit of the photographs at the Montana Historical Society in 1991, I was unprepared for the quality of the photographs: how remarkable Evelyn's eye, how beautifully composed the images. I walked through the exhibit feeling overwhelmed. Here were the landscapes that hadn't changed since her time — the badlands and the rivers — coupled with scenes of early white settlers on the plains. Thereafter, whenever I visited Glendive, someone brought up Donna Lucey's book and Evelyn Cameron. Many people shared my sentiment — Evelyn had given form to what we knew as interesting and beautiful.

The photo I found most arresting was of a German picnic on a July day in 1913. I, too, had attended summer picnics at my great uncle Buck's place. Here were the children who came before my siblings and cousins and me. Girls wore white dresses, their hair in braids wrapped across their heads or tied back in bows, two in linen scarves too large for their round faces, some clasping handkerchiefs. The only boy sat in the center, looking out of place in a sailor suit and heavy stockings, reminiscent of a sailor suit my little brother wore at the same age.

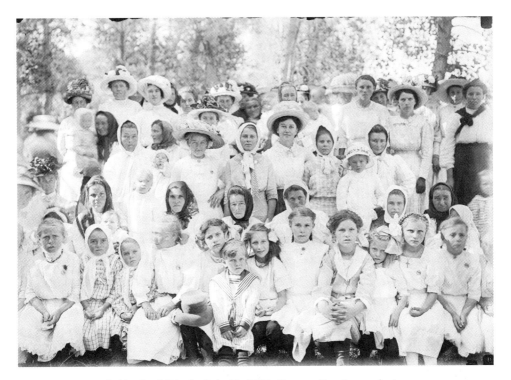

Cabin Creek Picnic, July 13, 1913, German Russian gathering

And the women—also in white—faces shaded by straw hats bedecked with flowers, or veiled in lacy black scarves. One stands with her left hand on her hip and sports a slight smile, while others seem burdened by the work left behind.

The women stand four, five rows deep, blurring as the depth of field fades. I see someone who has the countenance of my sister, one who resembles my mother's close friend, another surely a relative of my country friend from fourth grade. I do what I did as a child—I find the woman I'd like to be. Not worn out or dispirited, she's pretty but not too pretty, with a touch of mystery.

While these women hold my interest, by the time I finish the exhibit I realize it's Evelyn I'd most like to be. Like her, I love

manual labor and "ornithological ramblings." Hands down I would have chosen life in eastern Montana over gentility in England. She is more daring than I, but I too am happiest when out-of-doors. Yet mostly I admire her spirit. When her husband, Ewen, wanted to return to England, she found reason to stay or brought them back to Montana to try again. She had the resourcefulness and tenacity to survive in what my father calls a "hardscrabble place."

The exhibit rekindled a youthful dream of mine to write biographies on women for young people. I had Lucey's book for initial exposure and thirty-five years worth of Evelyn's diaries at the Montana Historical Society Research Center. Ten busy years passed before I could begin reading and researching, but when I did, I was not disappointed. Now I feel as if I know Evelyn

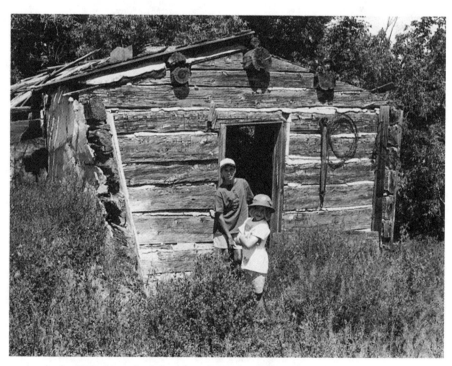

In 1997 the author's daughters visit the third Eve Ranch on a research expedition. The cabin has since collapsed.

through her words as well as her pictures. Although it has taken me another ten years to finish the book, I haven't grown tired of Evelyn. I still enjoy the afternoons I spend with her and Ewen, learning more about the country I grew up in and the ways in which another human being navigated a lifetime. I am grateful she took the time to document her world. Evelyn was, as we say, well suited for life along the Yellowstone River. And in being so, she has made us all look good.

ACKNOWLEDGMENTS

The first to thank are the archivists at the Montana Historical Society's Research Center. For ten plus years they have gathered the materials and carted them up the stairs, led me through the photographs, helped with the technical, ever cheerful. My sincere gratitude.

Thanks to my colleagues at Carroll College: Kay Satre, who gave me time to write; Melissa Kwasny and Virginia Cooper, who knew what to say; Cathi Burgoyne, Bradley Hansen, Peggy Kude, Kathy Martin, and Heather Navratil, who shared their knowledge and research skills. More thanks to Gwynn Mundinger, Nathalie Caulliez, and Elvira Roncalli, who helped translate German, French, and Italian passages.

Acknowledgment to doctors Greg Johnson and Spencer Shropshire for advice on medical matters.

Gratitude to my good friends—Patti Borneman, Gay Eyman, Cindy Hanson, Connie Johnson, Janice Miller, Lois Neal, Carol Schmidt, Gail Speck, Ann Wilsnack—for welcoming Evelyn into our conversations. And to my writing friends, Lisa Bay, Jan Donaldson, and Lynn James, for making me better. As well as to my editors, Gwen McKenna and Jennifer Carey, whose good vision added depth and clarity.

Affection to my old friends who shared the experience of the western prairie, the badlands, and the Yellowstone River, especially Cindy Kolberg, Gloria Zuroff, Peggy Roe, Eileen Freistone, Sari Hunter, and Debra Suhr.

To my daughters, Ryann and Shauna, who copied material in the early days, listened to chapters, advised and loved me—you encourage me in all ways. And a special thanks to Erik Van Dis, who lightened my farm work and added good direction.

To Jon, captive audience as we drove, how you listened and suggested—the best critic and thesaurus in my galaxy. To you, I am indebted. You are much loved.

Love and thanks to my eastern Montana family—my brothers and father for helping me find my way in the country, and my sisters for hiking into the hills with me.

Finally, thanks to the late Winona Breen, in addition to Tricia Harding and the diary transcribers of Terry, Montana. Your understanding and work on behalf of the Camerons helped bring this book to fruition.

This book was inspired by my parents, Iris (England) and Curtis Milne, embodiments of the virtues of eastern Montanans, a good and kind people.

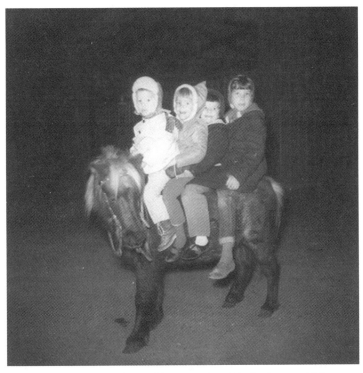

Lorna Milne and three siblings on their Shetland pony, Chico, circa 1963, Glendive, Montana. Milne is second from the back.

— 1 —
ALMOST A HONEYMOON
1889–1891

EVELYN JEPHSON FLOWER was born on August 26, 1868, in London, England, to a merchant father and a musical mother. She was the eighth born in her father's second family, with three surviving older brothers, Severin, Percy, and Alexander (Alec), and an older sister, Hilda. As part of the upper class, Evelyn and Hilda received a good education. They were educated by a governess, however, rather than in the private schools her brothers attended.

Not much is known about Evelyn's childhood. We do know she was a natural tomboy, preferring riding horses and hunting to domestic activities. Her penchant for adventure led Evelyn to Ewen Somerled Cameron, a family friend who was thirteen years her senior and married. Percy hunted with Ewen on the Orkney Islands off the north coast of Scotland, where Ewen lived. Evelyn may have visited Ewen's wild retreat as well.

Years later, after she reached adulthood, it was likely Evelyn who suggested she and Ewen travel together to eastern Montana to hunt big game. Evelyn must have concluded 4,500 miles was the right distance to put between herself and her mother, who didn't approve of her traipsing off with a not-yet-divorced man. The timing was interesting in other ways as well. Two weeks before arriving in New York City in September 1889, Evelyn had turned twenty-one. At this age she received a substantial trust payment from the estate of her long-deceased father, which surely helped fund the excursion. And, added to the family insult.

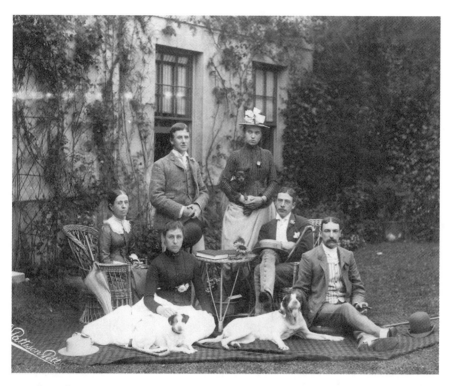

A formal portrait of Evelyn's family taken near their country home in England, before Evelyn traveled to America. Her mother is sitting in the wicker chair on the left; Hilda and Percy are sitting on the rug next to the dogs. Severin is in the second chair. Evelyn is standing with the dog in her arms, and Alec, the brother who comes to Montana with her, stands next to her.

How Evelyn and Ewen voyaged to the United States is a bit of a mystery. Ewen's divorce from the American opera singer Julia Wheelock wasn't final until October 17, 1889, well into Evelyn and Ewen's travels. Ewen married Julia in Nice, France, in 1881. Julia—who went by her professional name Madame Giulia Valda—toured with opera companies for at least six months each year, while Ewen resided in the Orkneys. Hardly a recipe for an intimate married life.

Ship records from September 1889 show Evelyn Flower and Madame Valda listed together, indicating they shared a berth on the ocean liner the *Teutonic*. Indeed, these were the years Julia

toured extensively, but was she on this ship or was Madame Valda really Ewen? At any rate, it is a puzzling transition.

Although Ewen was still legally married for about one month into their Montana trip, both he and Evelyn referred to one another as husband and wife and presented themselves as the married Camerons. Nonetheless, those back home knew differently, making this a daring trip by nineteenth-century standards.

For this western trek, the Camerons had reliable advice to depend on. During most of the nineteenth century, well-to-do British had been traveling to the American West for adventure, including Evelyn's brother Percy. Years earlier, before the railroad was through, Percy had hunted along the Yellowstone River as far west as Miles City. A broad turbid waterway that winds its way through cottonwood bottomland, the Yellowstone corridor and its islands were good hunting. By the time Evelyn and Ewen set out, they could take a train to Miles City, where they could buy supplies and stock, as well as find guides.

On November 1, 1889, the year of Montana's statehood, the Camerons started on the first of their annual fall hunting trips. They set up camp east of Miles City in the Powder River valley — the very valley that had been promised to the region's Indian peoples as their hunting grounds. The Camerons' party included both a cook and a guide, a luxury they could rarely afford in the years to come. While their cook, Mark, was English, assuring them of their puddings, their hunting guide was of another sort. John Montague, or Monty, had been a buffalo hunter and one of General Armstrong Custer's scouts. Only thirteen years earlier, in the Battle of the Little Bighorn, Custer foolishly led his entire unit of 265 men to their deaths, west of where the Camerons now hunted. And by 1889, thanks to the buffalo hunters, most of the buffalo had been slaughtered — rendering Monty unemployed. So Monty became a hunting guide, and the Camerons, both excellent shots and sports people, became his clients.

They began by hunting deer, antelope, and mountain lion on Cabin Creek, a drainage that zigzags through southeastern Montana before joining the Yellowstone River. While western Montana was heavily populated by the day's standards, around one hundred thousand people, eastern Montana was still Indian country, with settlers gathered around the few towns. Ewen described Cabin Creek as "a country of rough bad-lands, impervious gulches, dark cedar patches, just such a country as the puma prefers." The Camerons had seen deer in Scotland, but stalking mountain lion in terrain like Cabin Creek was a first.

Evelyn wrote:

> One day the three of us were out when we succeeded in starting a fine large lion. I had the first shot but missed. . . . The terrified animal rushed past us and into a hole in the washout for safety. Monty ran below to dislodge it, when, frightened past all sense of prudence, the lion darted out of his hole and jumped right up where we were standing. It was then our turn to be scared, not only for ourselves but for the guide. A shot from my husband's rifle brought down the lion before he had had time to do any mischief, however.

That winter the Camerons holed up near the Northern Cheyenne Indian Reservation, helping out a friend who was losing his sheep to a lion. At last count, twenty-eight sheep, Evelyn reported. She summarized their effort:

> Well, we hunted mountain lion on Pumpkin Creek all that winter, but we never got another chance at one like that we had over on Cabin Creek. We heard constantly of lions being sighted and of their jumping into the sheep pens and throttling the sheep, and we came upon a number of their holes and smoked them out. But we never had much luck with it all, so in the spring of '90 we gave it up and started off on a bear hunt on the north side of the Yellowstone.

The Camerons had heard about a rancher, F. A. Lisk, who had a reputation as a bear hunter. Lisk had a bunch of cattle in the breaks (deep gullies) along the Missouri River. Much like the buffalo, the

bear population had plummeted from the fifty thousand Lewis and Clark recorded in the early 1800s. Unlike other species, however, bears had no seasonal hunting protection through state law, so they were fair game in spring. Ewen offered Lisk $75 if he could show them a "silver tip," or grizzly bear. If no bear was roused, Lisk's services as guide and hunter would be free, the two men agreed. Monty made no such agreement.

On March 15 the Cameron party left Miles City on a trip that was to last two months. Ewen recounted the conditions for a British newspaper in an article titled: "A Trip After Bear in the Missouri Brakes [*sic*], Montana":

> As our hunting ground lay about 100 miles north of Miles City, and the other side of the Yellowstone, this river had to be passed over on the ice. . . . At this time of year, with the warm weather prevailing, it seemed at first that any attempt to cross with our waggons [*sic*] would be little short of madness. However, as it was a case of crossing the river or bidding good-bye to the bears, we determined, not without some anxiety, to make the attempt . . . although the water in places was several feet deep on top of the ice.

Once safely on the north side, Lisk remarked that the crossing couldn't have been done by sundown of the same day. A close shave, Ewen called it.

The party—Lisk, Monty, Mark, plus the Camerons—was well outfitted: two wagons for the horses' feed and their own provisions, eleven saddle horses, and a couple of dogs. Although Evelyn eventually pioneered a split skirt and learned to ride astride a horse, on this trip she rode sidesaddle. Mark drove one wagon, drawn by a pair of mules. The other wagon was led by two horses and driven by Monty, "who on this occasion was resplendent with new hat, new gloves, and new whip," having received his winter's wages. Even spiffed up, this was not an expedition Monty fancied. He had never been to the Missouri Breaks and wasn't eager to go, grumbling that, "bears could *only* be found in deep draws filled with brush"—a place no one wants to encounter a grizzly.

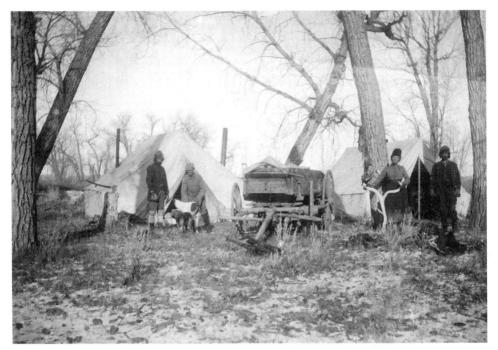

Hunting camp, likely on the mouth of Timber Creek in the Missouri Breaks. Notice the antlers Evelyn is holding up, and the hunting dogs next to the men. Also, the stove pipes sticking out of the cook tent. Ewen is probably on the far left. The guides, Monty and Lisk, and the cook, Mark, round out the party.

The Cameron party covered eighty miles in four days, some of it arduous because of the heavy wagons. They encountered snowy owls, coyotes, antelope, scores of bleached buffalo skeletons, and buffalo heads, some with the hair still on them. Evelyn picked up some good horns for polishing.

On the fourth night they pitched their tents "in a gorge between mountains, with precipices yawning upon two sides." Lisk called this site Success Camp and told them that no white person but himself, to his knowledge, had hunted from this place. This put them all in good humor, except for Monty, "who swore at the darkness and the inconvenience of the locality." They fell asleep to the howling of coyotes and wolves.

Come daylight, Ewen took it all in:

> This morning I rode my horse to the top of a high divide near camp to take a look at the famous bear country called the Missouri Brakes [*sic*]. Forty miles of what appeared to be all bad lands lay stretched before me an interminable desert of clay buttes, their utter desolation only relieved here and there by a silver streak, the Big Dry river often lost to view in the leafless cotton woods on its banks. These buttes were of many colours—red, blue, golden, and grey, but the blue and the grey predominated. Some were variegated and looked almost as though they had been painted in even layers.

Certainly Evelyn knew that grizzly bears were the most daring animal to pursue in North America, yet she doesn't express wariness. Evelyn had grown up chasing small game such as rabbits and grouse with her brothers on her father's estate. So this outing, the only woman in a party of five, must have felt familiar. Based on their experiences, all but Monty—who was seventeen years Ewen's senior—were close in age to Ewen, and compatible with twenty-one-year-old Evelyn, who was spunky and hardy, an ideal camping companion.

The Camerons did have time alone, scouting coulees on their own, sometimes following old Indian trails, then rendezvousing with Lisk in late afternoon. On one such day, Ewen started two bobcats under his horse, which bounded across the divide. Evelyn took off after them and shot twice at seventy yards across a ravine, wounding one. Ewen described the chase:

> Although encumbered with habit skirt and rifle, E. [Evelyn] followed the now blood-bespattered trail, climbing and slipping until she reached the upper ridge over which the lynx [bobcat] had passed. Partly riding and partly leading my horse, I hastened to get to this point so as to throw in the hound, Queen. . . . The old hound took the trail with fury, and off she went down the steep hillside, her hair standing on end, and baying loudly. On a headlong run E. followed her, and both were soon lost to view in the depths of a canyon.

When Ewen and Lisk found her, "E. was working hard to smoke the beast out, . . . E. had run about a mile at the trail of the hound over buttes, round boulders, and across deep cut gullies, carrying her rifle, and was greatly heated with her exertions."

A small-framed agile woman, Evelyn was also strong. One night, camped in the gorge, a thunder and lightning squall nearly blew them into the wash, which was full of water from the storm. Ewen wrote that they spent the night holding onto their tent poles when violent gusts struck, fearful that their stove would tip and cause a fire.

The next morning, the wind still howling, they all agreed to move camp nineteen miles to the mouth of Timber Creek, "a river bottom heavily timbered and hemmed in by mountains." Evelyn and Ewen rode ahead and built a fire in the fireplace of the windowless ranch house to warm the men upon their arrival. A western meadowlark warbled a greeting from the cottonwoods. At the site of an old cattle outfit—which had been deserted on account of marauding bears—the Camerons found "warnings chalked upon the buildings against these animals."

From this new camp they set out again each morning, Monty and Lisk—who were steadily growing at odds with one another on guiding technique—each on their own, and the Camerons together. When they met up with Lisk one afternoon he wanted to show them some geological formations, which looked "like the ruins of old red fortresses that had been thrown from their mounds." Although Ewen was dispirited and disinclined to make the detour, Evelyn was eager and it was fortunate she was. For as they turned to leave the ruins, Ewen spotted what he believed to be Monty leading his horse and stalking some kind of game about three-quarters of a mile away. Evelyn and Lisk saw the figures at the same time, and "Lisk assured us that what we saw could be nothing more nor less than a bear," Ewen recalled.

As the sun was setting, Evelyn and Ewen hurried to a sandstone ledge above the sow and her two cubs as they came winding up a

gully. They left the horses with Lisk, then crawled into position, reaching their "ambush just before the little family had arrived," Ewen recounted. "She [the sow] was intent upon devouring a kind of plant like sage brush, and was so close I felt I could almost touch her. The cubs were a little way behind, still barking and indulging in absurd gambols."

Evelyn narrated:

> My husband had the first shot. He hit the old bear squarely in the side. Falling over, the wounded bear made gallant and pathetic efforts to shield her cubs from our rifles. She would bang at them, first with one paw, then with the other, slapping them as hard as she could with her waning strength to make them get on the farther side of her.
>
> "Now it is your turn," said my husband. "I fired. . . . She never rose again."

Although Evelyn could write matter-of-factly about killing the bear, she cared a great deal for wildlife, as is shown through her empathy for the cubs: "The cubs sensing the hard fact that their protector was dead, got on her body and began to lap it and nozzle it, doing their best in their poor confused way to waken it to its old motherly warmth and activity."

After they skinned the bear and coupled the cubs together with Ewen's saddle rope, they managed to strap the hide onto Ewen's horse. But when his horse caught scent of the bear, all havoc ensued. In the uproar the cubs escaped, mistaking Evelyn's steed for their mother and "ambled towards him with cries of affection," Ewen recounted. The horse "retreated, grazing as he went, and kicking at the bears. Evelyn, in her endeavours to recapture the little monsters and save them from horrible injuries and perchance death, received a spent kick on her knee, which afterwards made a severe bruise."

With Ewen's horse worn out, it was left to Lisk and Evelyn to carry the cubs, Evelyn on her sidesaddle. In the light of a quarter moon they started back to camp under protest from their charges.

Ewen wrote:

> The young bears were about the size and weight of our hound, a
> thickset and solid animal. They kept up their shrieking and roaring
> without any intermission all the way to camp, so that it was next to
> impossible for us to speak to each other, except when we crossed
> the Big Dry river, and the little brutes were awed into silence by the
> sight of the dark rushing water beneath them.

As the march dragged on, Ewen realized they were hopelessly
lost, but Lisk only admitted to being "a little turned around." By
the night's end they had forded the river—which was swollen with
snowmelt—four times instead of the once required.

After waking everyone the next morning with their "incessant
shrieking," the cubs eagerly lapped Evelyn's concoction of
condensed milk mixed with warm water. Mark was appointed to

*The grizzly bear cubs chained to a log. Ewen described their cry as "strongly
resembled the sound made by a powerful saw when used in sawing wood, but as
they grew older this was exchanged for the short muffled roar of the parent."*

care for the cubs because he had been staying in camp in case of wandering Cheyennes. Monty was on friendly terms with Two Moons, chief of the Cheyennes. Monty informed the Camerons that the Indians were not receiving the promised food allotments on the reservations, and "under these circumstances [might] run off with the horses and steal the provisions, although with a man in charge they would probably give it a wide berth."

The two guides and the Camerons continued to hunt, and after a harried pursuit with his horse, Lisk killed a male bear that Ewen called "the parent of our cubs." Even so, Ewen was frustrated that they had only killed two bears. They had been close to eight bears, he estimated, all of which they might have shot with a good dog. This, plus the tension caused by "the absence of harmony between our hunters," made up Ewen's mind to pull out for Miles City. They didn't have a good dog on this trip because many dogs had been poisoned by bait put out for wolves. The remaining dogs were too valuable to be sold. Ewen had offered one man $50 for his sheep dog, which also tracked, but the man refused.

Believing the warm weather to have broken up the ice enough for the ferry to cross, they started back on April 6, three weeks into their badlands trip. Evelyn and Ewen scouted migrating ducks along the way. Ewen shot them and Evelyn and her horse waded into the frigid waters to retrieve them. In Miles City people flocked to the stables to see the cubs.

Back in town Evelyn fed cows' milk to the cubs but they nearly died from diarrhea. She returned to condensed milk, and when they were six weeks old she added porridge of mixed oatmeal and Indian meal. As the cubs became acclimated to people, the Camerons decided to ship them to the London Zoological Gardens, which had lost its last grizzly six months before.

From our distant perspective it seems a terrible waste to have killed a mother bear for sport and her hide, and send the cubs across a continent and an ocean to cramped quarters in a zoo. In 1890 European sport hunters and settlers largely viewed bears

as dispensable, an attitude that years later would be mourned. Although the Camerons hunted bears, their philosophy was more complex. In Evelyn's diaries and Ewen's articles they expressed their frustrations over cruel and shortsighted conservation practices. While in the Missouri Breaks, Ewen stated his dismay at the killing of forty mule deer in the space of a week by another hunter: "Such a slaughter truly exasperated my sportsman's soul: but what could I say to my friend, who was a charming and most agreeable young American."

Like-minded, Evelyn lamented in her diary how the antelope faced extinction because they were used as poisoned bait for wolves. This practice also devastated the golden eagles feeding on the poisoned antelope carcasses. Perhaps the most poignant loss Evelyn chronicled in a letter to Ewen's mother, Mrs. Cameron. By 1895, she wrote, they no longer saw grizzly bear sign in the Missouri Breaks.

As Evelyn and Ewen matured, they changed. At twenty-one, Evelyn shot the sow; at fifty-one, she may have photographed it.

Eleven years later, in 1901, as the Camerons were making their way back to Montana after a winter's stay in Scotland, they stopped to visit the now-adult bears in London. Evelyn wrote: "We took 4 wheeler [car] and drove to zoo. . . . Saw the bears and many more. One of ours is much larger than other and it had a cute way of rattling a bar (lose) to attract attention. Lions, antelope etc."

Even though they'd never see the bears again, the Camerons didn't forget about them. We know from a 1914 article that the two female grizzly bears "which have lived side by side in the dark and gloomy cages on the north side of the terrace since 1890" were moved. The bears received better quarters because Ewen requested photographs of them to share with another scientist.

Evelyn and Ewen's adventurous honeymoon—the trip that led to Montana grizzlies living out their lives in a British zoo—was the

first of many long forays the Camerons took into the badlands. Sometimes they hired a cook, often they went with friends, and before long they became the guides. Evelyn waxed poetic about the sporting life:

> Where the wife shows any liking at all for life in the open I consider a hunting expedition one of the most desirable ways for a couple to spend a holiday. It is wonderful what comradeship is developed between them. All sorts of cobwebs get blown away in the long days together on the windswept prairies or in the gulches and trails of the Bad Lands.

We know the Camerons stayed on in the Powder River area at least until August 1, 1890, whereupon they returned to England to gather their possessions. They packed up and immigrated to Montana in September 1891, along with Evelyn's troublesome brother, Alec, who was just twenty-four, one year older than Evelyn. Evelyn's diaries from the first three years of their life together are missing, and when they pick up, in 1893, money worries and Ewen's health preoccupy her. But for their first Montana venture, we see them as hopeful and excited by their experiences. This introduction to Montana may have defined their partnership for the rest of their lives. Certainly, it set the tone: Ewen, gentleman scientist and first-rate hunter; Evelyn, hard working, spirited, and ever resourceful.

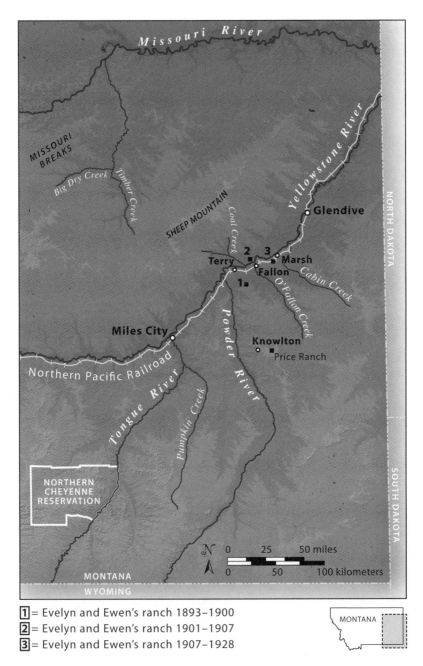

Missouri River

MISSOURI BREAKS

Big Dry Creek

Timber Creek

SHEEP MOUNTAIN

Coal Creek

Yellowstone River

Glendive

NORTH DAKOTA

2 3
Terry Marsh
Fallon
1

Cabin Creek

O'Fallon Creek

Miles City

Powder River

Knowlton
Price Ranch

Northern Pacific Railroad

Tongue River

Pumpkin Creek

NORTHERN
CHEYENNE
RESERVATION

SOUTH DAKOTA

N

| 0 | 25 | 50 miles |

| 0 | 50 | 100 kilometers |

MONTANA
WYOMING

1 = Evelyn and Ewen's ranch 1893–1900
2 = Evelyn and Ewen's ranch 1901–1907
3 = Evelyn and Ewen's ranch 1907–1928

MONTANA

The eastern Montana country where Evelyn and Ewen lived.

— 2 —
TROUBLESOME TIMES
1893

IF THERE WAS A YEAR that could be described as having more than its share of troubles, 1893 was it. In 1891 the Camerons had rented a place on the Powder River among other British expatriates, but in the winter of 1893 they moved to a ranch more practical on which to breed and train polo ponies. Polo ponies are not really ponies. Typically, they are full-sized horses bred to be agile. The ponies need to be nimble because polo is played by driving a wooden ball into the opposing team's goal, using a long-handled mallet. From the new ranch, which they called Eve Ranch, the Northern Pacific Railroad depot was just six miles north at Terry. Here they could ship the ponies to the Atlantic Coast, where they'd be freighted aboard a steamer to England.

At least that was the plan. Their resettlement couldn't protect them from the hard winter, or from a financial crisis, known as the Panic of 1893, when money and credit dried up. Nor could the move solve Ewen's nagging health problems. Last of all, relocating didn't relieve them of Evelyn's brother Alec. It would be seven more years before they'd see Alec back to England.

Several times in 1893, beginning in January, Ewen traveled to Miles City to talk with creditors or potential partners in the horse business. Ewen was seldom successful on these trips, and Evelyn missed him when he was gone. When one stay dragged on for two weeks she asked, "Wonder how poor old Ewen is progressing, wish he were here."

Ewen's absence ended on Valentine's Day; he was carted home from the depot in Monty's sleigh: "Ewen came home, great delight....

They arrived at 1:15. Had lit fire as soon as I saw them, in our room. Monty came in & warmed his hands, said this cold was lasting longer than it did in hard winter (86–87.) 25% dead already of cattle, seen 5 in one draw dead."

Often Ewen returned ill or became sick soon after, causing Evelyn considerable work and worry. After Monty departed, Evelyn "sat with Ewen, got a nasty cold coming on." And four days later, "Ewen rather worse. Anxious." Caring for Ewen, she observed: "Rubbed Ewen's back. Hands are rough from picking up potatoes." Two days later Evelyn applied linseed and mustard poultices to Ewen's throat, without any substantial relief.

Alec, on the other hand, seemed to be the epitome of health, perhaps because he never exerted himself enough to use his reserves. That winter Evelyn wrote, "Alec had had enough of carrying coal, no doubt he is fearfully lazy." And the next spring, after she and Alec planted corn, "Down to the ½ acre patch . . . I did most of the work. Alec's back soon gave out & he goes so terribly slow." Despite his poor character, Alec helped Evelyn with chores more than Ewen did. He cleaned up after meals, sawed logs and carried coal for the stoves, whitewashed the rooms, and helped in the garden. When Ewen was away, Alec provided some company and cheer. "After awhile I told Alec to come & sit with me so he came & cleaned his two guns." And on a terribly cold February day, Evelyn wrote, "Have sort of gloomy feeling, suppose whistling of wind. Alec's bright face dispelled it tho'."

Notwithstanding challenges on the Alec front, Evelyn managed to keep a sense of humor regarding him. "Alec tumbled off hay wagon onto his head to day & rather hurt himself, thus practically sound," she chronicled, implying that the knock did him some good.

As part of the national financial collapse, the Camerons lost the money they had deposited in the Miles City bank: "Stock Grower's Bank failed, many great losses. Ewen cabled Wickham [Evelyn's cousin who managed her trust] not to send money to Stock Grower's." The bank failure was the last straw for Ewen,

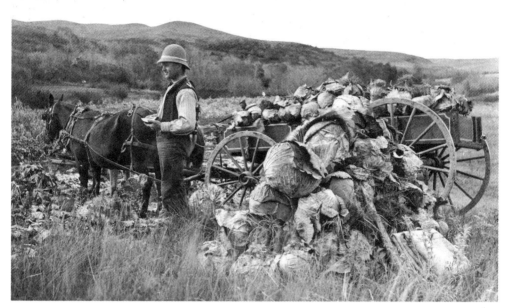

Alec Flower eats a watermelon in the midst of the cabbage harvest of 1898. Alec and Evelyn planted 740 cabbages that spring. When Alec wasn't sauntering off to Terry, he helped Evelyn in the garden and shared in the profits. He also picked gooseberries to sell.

and he advocated going home. One August day, while Evelyn sat mending a shirt of Alec's, "Ewen talked incessantly the whole time on our future plans, living at home, giving up all here etc." Ten days later Ewen was still lobbying for a return to England. But not Evelyn, "I think it would cause congestion of our finances again & no ultimate good attained out here. There is some chance of money making even if we kept quiet, saved, bought & sold horses." Ultimately, Evelyn convinced him they should at least hang on until spring.

Evelyn's pluck and stamina also served their daily efforts at subsistence. Hunting for sport was familiar to the Camerons; however, hunting and gathering out of necessity was not. When they ran out of meat mid-August, Evelyn summarized: "No bacon,

no nothing. Shot grouse to make up the deficiency." Dinner consisted of, "Broiled the grouse (fried), fried potatoes, sweet corn, bread pudding, tea." Evelyn grew the potatoes and corn, baked the bread, and with the help of their hunting dogs, she and Ewen shot the grouse.

In keeping with the tradition of sharing what one had in abundance, their meat shortage was temporarily remedied when a long-time rancher, Mrs. Kempton, gave Evelyn some fish. "Birney Kempton had got over 100 sturgeon & catfish in Powder River, caught with his hands. Gave me some salted."

Still in need of meat, Ewen was off by 7:30 to hunt, an early hour for him. Evelyn reported that after Ewen missed a shot at an antelope he "got 2 fawns to please me. He had great compunctions [feelings of guilt] shooting them." Likely Ewen didn't think it fair game to shoot fawns. Yet they had hunted for several days without success, and Evelyn felt the added responsibility for feeding Selby, a man they had hired to help with fencing and putting up hay.

The Camerons too shared meat when they had extra. "Ewen & Selby drove in wagon over to square topped butte & brought in the two deer, leaving hind quarters of one at Henry's."

Within a few days their friend Mr. Coggshall dropped off fourteen pounds of beef on his way to ship his cattle, further relieving their shortage. Evelyn salted it down along with the deer. That evening they feasted: "Cooked sweet corn, potatoes, roast beef, venison cutlets, cornstarch, cherry preserve, cream etc., cucumber."

Throughout the fall they continued to hunt, sometimes for grouse and ducks, but mostly for deer. In early November, after the weather turned cold enough to keep meat without refrigeration, the Camerons left for a twenty-day hunting trip on Cabin Creek without Alec.

Hunting wasn't the only break the Camerons had from Alec and work. Intending to publish a comprehensive list, Ewen was steadily collecting data on the birds of Custer and Dawson Counties. In

the early days of ornithology, in addition to fieldwork, scientists studied wild birds by capturing or shooting them. Because few specimens existed, ornithologists skinned and mounted the birds for reference. The same went for eggs—one day Evelyn "blew eggs for Ewen, 5 sparrow hawks [kestrels], & 1 flicker's."

Ewen became quite expert at knowing where to look for nests of certain species. Concerning lark buntings he wrote: "Their nests are more plentiful in fenced pastures than elsewhere, a fact explained by the bird's fondness for perching on the wires. I have observed five nests in one small pasture when riding through it, and, had search been made, doubtless many more might have been discovered."

Evelyn accompanied Ewen whenever she could. On May 28, they spent an especially rewarding day in the field:

> Rode South along the Terry road. Ewen shot a collard bunting. Saw two rather buffy coloured buzzards. One had caught a prairie dog & was feasting thereon. Ewen tried to get near for a shot but it got up & his shot had no effect at the distance. Ate lunch near old sheep camp this side ten mile. . . . Across the creek up into mountain lion rocks, pines & cedars. Ewen found a red pole's [*sic*] nest, took two eggs, 4 in nest. Saw no new kind of flower as hoped.

Evelyn ended the entry for that day with mention of Ewen's first wife: "Mrs. Cameron said in her letter of yesterday that Julia gave a concert at Tunwells & a charity concert also. Ritts & Bassett spoke to her. —Julia got a lovely flat in Victoria Street, thick with an equerry [horseman] of the Duke of Edinburgh."

It appeared Julia still preferred men who were good with horses.

In the northern plains most berries ripen in July and August. Along with their neighbors, Evelyn, Ewen, and Alec spent hours harvesting fruit. They picked serviceberries, gooseberries, currants, chokecherries, and plums, experiencing special satisfaction in coming home with a new find. "Ewen & I to his discovery of thickly ladened currants & gooseberry bushes, picked hard," Evelyn wrote on July 24.

Mostly Evelyn made preserves from their discoveries, yet she improvised to please their English palates. One August day she made a suet wild currant pudding, which "Selby said pudding best he had tasted since being in America." And on another, "Out & gathered chokecherries, Ewen, Alec, Selby & I, for a tart, got a lot." Evelyn also baked chokecherry pieletto, a flannel cake (pancake) with cherry jam inside, and even cornstarch jelly pie. But she mainly spent hours at the stove boiling fruit down into jams and jellies. The chokecherries proved challenging.

"I borrowed the machine for taking stones out of cherries from Drew, Mrs. She will not require it for a few days." After picking 20 pounds of chokecherries and Alec another 22, Evelyn settled into jelly making. "Tried till 3:30 to make cherry stoning machine go right. . . . I decided to go & get Mrs. Kempton's. . . . Mrs. Kempton was working her machine & showed me the ropes thereof." Without a ready supply of canning jars, they broke the tops off old bottles to use. "Alec broke bottles for me with iron red heated ring, for jelly."

In order to make their beloved puddings (or feed Winona, Evelyn's pet antelope), Evelyn needed milk. When their cow dried up or they had to return a cow that had been loaned to them, they scrambled to find another. On July 8, Evelyn recorded, "Ewen got loan of cow, wonderful milker. Got to fetch her tomorrow."

The most careful of planning couldn't prevent the shortage of staples. In early September, when the cattle were being shipped to market, cattle cars replaced the freight cars, delaying the delivery of groceries. Evelyn fretted, "No flour now, used last in biscuits tonight!"

Evelyn's garden helped make up the deficit, providing sweet corn, turnips, potatoes, beans, cucumbers, and an unripe watermelon. Hearing of their shortage, their neighbor Henry "said he would let us have little flour till ours came."

As the only practical way to keep well-stocked in rural areas, the Camerons purchased in quantity: "200 [pounds] flour, 100 sugar,

Evelyn made bread about once a week, averaging seven loaves each time. She sponged bread the first day — likely saving a bit of yeasty dough from batch to batch to start with — then worked it and baked it the next day.

100 oatmeal, 50 [cans] sago [a starch extracted from tropical palm stems, similar to tapioca], 37 pounds ham, 10 pounds lard, 100 cornmeal," plus, "Ewen got 4 dozen eggs from Braleys." They must have felt replete, sharing a "lunch of ham, omlet, fried potatoes, scones made of sago & plums," after which Evelyn "worked bread into loaves."

While Evelyn, Ewen, and Alec scouted for game and fruit, tended vegetables, and waited on trains, the hired hand Selby — with occasional help from Alec — built a fence around their grassland. This reflected the shift coming to the high plains: the transition from open range to partitioned grazing fields. Nearly finished stringing wire, Selby was hurt: "They are now coming this way home with the fence, the most difficult part. The barb wire broke & cut Selby's hand, spliced wire again all right."

Mid-September Evelyn reported, "Fence taken 4 week & 3 days. . . . Alec very delighted at having got fence done, most work he has ever done." With their land secure, Evelyn and Ewen cleared out the neighbors' stock, about 200 steers: "Ewen & I down meadow into new pasture, got the cattle rounded up. I managed to send on through the wire, which slackened it." Now the Camerons' horses, steers, and milk cows could graze within the fenced area, making them easier to find and to feed.

Another adjustment eased Evelyn's work a bit. Back in February, Ewen had brought three hunting hounds home from Miles City. They proved poor trackers in the rough country around their place and difficult to keep fed — Evelyn having to grub potatoes or lead them to scavenge dead animals. So when word came of someone willing to adopt them, Evelyn was ecstatic: "Great joy, Mr. ? written to say he accepts the hounds (as a present) & would like them sent to Miles [City] directly. I am so glad to be able to get rid of them."

Even though Evelyn conducted her life in much the same fashion as the other pioneers, she had a strong sense of social expectations consistent with her upbringing. She made note of when she spiffed up for company, at times making light of this etiquette in the outreaches of eastern Montana. Company's arrival after dinner prompted, "I changed into fine raiment [clothes]." And when the McDonalds appeared in the midst of their noon meal, she "changed skirt & boots hurriedly," then "got them some

dinner, chops, potatoe, cocoa." In England, Evelyn may have offered afternoon tea; in Montana, a meal was custom.

Changing one's clothes was a way to honor company; their presence made the day extraordinary, a break from routine. Evelyn also dressed up to show appreciation for something new or just finished, as if her better attire inaugurated a fenced pasture. The morning after the McDonalds' visit she "put on white silk blouse" to ride with Ewen into the hayfield.

Evelyn's good eye and appreciation for beauty, which she later expressed through her photography, is evident on nearly every page of her diary. With a neighbor she "walked back by dim moon." Or hunting ducks on Whitney Creek in early spring the "clouds hurried along overhead, reminded me of an English day." Even if Evelyn never intended for anyone to read her diaries, the audience is larger than herself in that she chronicled more than the routine.

On occasion, and certainly with more reserve than by today's standards, Evelyn vented her hurt feelings in her diary. The summer of 1893 Ewen seemed especially short tempered as they grappled with financial and personal problems, courted partners in the polo pony business, and debated whether or not to go back to England. After Evelyn spent a "very warm" morning digging out a reservoir, leading to a frugal lunch, "Ewen blew me up for not having enough to eat!" Consistently Evelyn proved the more level headed and mature of the two, despite being thirteen years younger. After his outburst Evelyn "had a talk with Ewen on straightforwardness."

Within weeks of her talk, he gave Evelyn "fits for being late" when her garden work delayed dinner. Ewen rarely helped prepare food, certainly never an entire meal, whereas food preparation took up most of Evelyn's time.

By September, after a long, hot, mosquito-ridden summer, Ewen's temper was worse: "Ewen gave it me hot 'fore breakfast, felt blue," Evelyn wrote, without explaining why he was mad.

Then at breakfast the very next day:

> Ewen took a fly out of cream & threw it on the boards. I told him I
> didn't like cream thrown on boards; he became mad with rage & flew
> into the other room. Later I went to try & appease his wrath, made
> him worse & cursed me 4 times as I went down the verandah steps
> 'cause I cried. I felt mighty bad & in the Avenue's solitude poured
> forth my heartache. To be cursed by him— ! Finished washing up.
> I had no breakfast, too big a lump in my throat to swallow.

Evelyn spent the afternoon pitting and stewing plums while
Ewen "wrote at his ornithological notes," with no apology
forthcoming.

By year's end they had resolved to take in boarders to help
with their expenses until the pony business began to pay. Evelyn
outlined their thinking to Mrs. Cameron:

> We have been so hard pushed lately that we have tried the plan of
> taking pupils [boarders] & one young man arrived from Ireland
> a short time ago. It is probable that he will put some money into
> this concern which should he not do so we shall probably give up
> ranching on our own account altogether & "hold down" a ranch for
> Mr. Wallop in the Big Horn mountains.

On the first Saturday in December, Evelyn readied the house
while Alec rode to pick up their boarder, his friend Mr. Adams:
"Alec rode Stockings to Terry & Henry in wagon to fetch Mr.
Adams. I slaved away at preparing supper. Changed & washed. . . .
Dressed. Mr. Adams & Alec arrived 7:30. . . . He speaks as well as
anybody tho' stone deaf. . . . He seems very intelligent. Told Ewen
he had capital."

Although Mr. Adams only lasted eight months and never did
invest in the ranch, he gave Evelyn her first instruction on what
was to become her life's passion: photography.

— 3 —
FINDING FOCUS
1894

THE FIRST INDICATION EVELYN GAVE that Mr. Adams may be something of interest to her—other than a third man to wash, mend, and cook for—was when he came back from picking up mail in Terry with photographs from Ireland: "Mr. Adams got 4 photos from home taken with his camera by his sister—very good indeed."

Evelyn often commented in her diary whenever she appreciated a photograph. Having a classical education, which included drawing and painting, it makes sense that Evelyn applied this aesthetic to the endeavor that became her most valued occupation.

Initially Mr. Adams appeared to be just what the Camerons had hoped for in terms of an investor to shore up the ranch. Adams and Ewen held several business talks during December. Their shared optimism went so far as Mr. Adams writing home for capital. By early January, however, Adams indicated he might not be as eager to invest in the ranch, rather he wanted to enjoy an extended stay: "Ewen had a business conversation with Mr. Adams morning, who said he was very grateful for us keeping him here & that if he couldn't raise the sum required would we keep him through winter; of course Ewen said yes. Mr. Adams said he would pay for board."

Adams's quick reversal may have been partly because of Alec's rudeness over sharing his room, yet Adams was also homesick. He often rode to Terry to retrieve the mail, hoping for letters: "Mr. Adams said he got 3 letters from home & would have gone 20 miles to get them." One of the letters may have come from the woman he said was his sweetheart: "Mr. Adams showed me the girl he

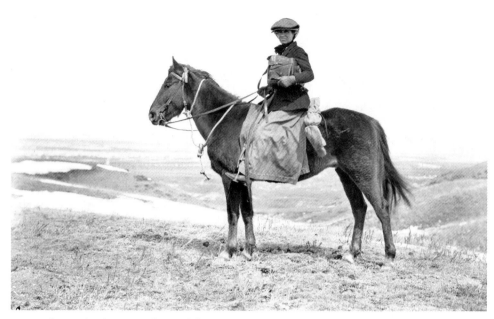

*Evelyn on her horse Trinket with her camera in the case and tripod tied behind the saddle.
Evelyn has her tam [a Scottish hat] secured with a scarf and dons a black wool jacket with
leather riding gloves. By 1911, when this photo was taken, she and the seamstresses in Terry
have perfected the divided skirt for riding.*

is engaged to in his photo book. Told him Miss Nellie looked
charming in her photo." A subsequent boarder, Mr. Colley, told
Evelyn, "He didn't know Mr. Adams was engaged," and Adams
was not "one to be believed, he is very inaccurate."

It soon became obvious, however, that Adams lacked the
aptitude for much of what their daily lives entailed, including
hunting: "Saw an antelope, he [Adams] kept on not seeing it &
put others on the run. . . . Mr. Adams got off & followed them
afoot. He got splendid close shot at them 60 or 80 yards off over
a rise, 2 shots & 2 more when good way off. . . . He fires in too
great a hurry." Adams also rode horses "without judgment, hands,

or sense," and seemed to lack common sense in general: "Mr. Adams rode home with porcupine skin in his pocket, the result was very uncomfortable." What Adams did have aptitude for was photography.

Interesting enough, it was Ewen who first talked about getting a camera: "Ewen says he'll get a camera in July," presumably because he wanted to illustrate his scientific articles. On July 25, 1894, Evelyn recorded that "Ewen wrote to Allen [supply business] for photo outfit." Just three weeks later they received word that a camera had arrived at the depot. Adams retrieved it and that evening: "Mr. Adams showed us all the photographic aperatus [sic] in his room."

After Adams taught Evelyn how to change the glass-plate negatives, she took her first photograph—"of the view down the creek"—with Adams's help. Adams also accompanied Evelyn on her first commission:

> Mr. Hamlin, the 2 Braley girls, Mr. Adams, Ewen & I down to meadow & chose a suitable background to be taken by. First Henry & his girl; Henry on Cotton, Miss B. on Buck, her father's horse, taken thus twice. Henry alone on Cotton, then Hamlin & Braley (Lester) together. Hamlin's bronco mare wouldn't stand still. Hamlin's child by the corral gate.

A few days before boarding a stock car in Fallon to make his way back to Ireland via Chicago, Adams took photographs with urgency: "Mr. Adams took the ranch looking north down the porch. I sat with Chips [cat] on my lap & Jan [dog] lying by me, Alec cleaning rook rifle by his window." The collaborators printed and toned up until the hour Adams departed. On her birthday, the very next day, Evelyn wrote: "It is quite a rest to be without Mr. Adams."

Evelyn's break didn't last long as they planned to ship polo ponies to England at the end of the week. To ready the ponies, the Camerons asked Mr. Drew to help braid their tails. Out of kindness, Evelyn helped the Drews out by taking their son Jack

home to spend the night. Jack had a reputation as being a handful, but like most creatures, he was docile under Evelyn's care:

> Drove little Jack home with us as Drew coming up in morn to bandage up the ponies' tails for the journey. Sup 7:30. Milked after. Jack hung on to me the whole time. He is a dear little boy; certainly he is not behaving like an enfant terrible as I expected he would. I slept on floor, Ewen slept in Adam's room, and Jack in our bed as Ewen is afraid of infection from scarlet fever.

Jack had recently recovered from scarlet fever, thus Ewen's worry was legitimate. Even so, his carefulness caused Ewen a sleepless night because bedbugs inhabited Adams's bed.

When Drew arrived to braid the tails of the spirited ponies, Evelyn chipped in: "I up & helped put tails in flannel. . . . The pale buckskin ($35) was a terror; he kicked, threw himself & did all he could that was mean. . . . Nancy resented having her tail touched

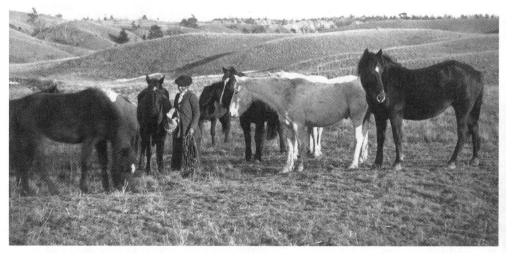

Evelyn in the pasture with feed bag and horse rope halter. When Evelyn worked with their polo ponies she practiced gentle breaking techniques. She commented in her diary when she saw men using too much force to break horses.

also." After they finished all twelve, Drew and Ewen drove the horses to Fallon. Mr. Braley accompanied them as far as New York City, where he then gave them "into the care of the Bond Stable Manager."

Evelyn's trips to town often served a dual purpose. Before going to see the horses shipped the next morning, she and Alec gathered vegetables from the garden to sell along the way:

> I dug potatoes, 14 pounds, plucked about 3 ½ bushels of tomatoes, cucumbers young & ready for sweet pickles, 8 cabbages, 2 cauliflowers, beets. Alec got butter beans & green beans. Harnessed up. . . . Stopt [sic] at a 101 outfit wagon on Fallon creek. Cook bought 3 cabbages & some beets, 85 cents. I [to] Mrs. J. Van's. She bought $1.80 worth tomatoes, 2 cents a pound. To Mrs. Lewis, Mrs. Collins who gave us beef pie & cake to take home! Gave her vegetables. To saloon near, man bought 4 cabbages for a waggon [outfit]. Mr. Allen & Ewen rode up. Horses just shipped, bother to get them in car. To Mrs. Laney's. She bought rest of tomatoes at 25 cents.

Once back at the cabin, Evelyn learned that Ewen was mad because she'd taken the wagon to Fallon, although why he'd be angry is unclear as she needed the wagon to haul the vegetables. Ewen slept with the bedbugs again.

Nearly four weeks after the ponies were shipped, Ewen received a cable from Drybrough: "'Horses arrived safely, good.' Made Ewen feel a little more happy, very blue last few days, so hard up." At the front of Evelyn's 1895 journal she posted a newspaper clipping titled: "The Edinburgh Polo Club." It read: "Some considerable interest was felt in watching the play of the Montana ponies imported by the Messrs. Drybrough. All these ponies played well. . . . Mr. 'Jack' Drybrough on Captain Bluff, a Montana purchase, opened the game by hitting the ball first. . . ."

Perhaps Captain Bluff was the "pale buckskin" who didn't want his tail touched? In early October, Mr. Drybrough wrote saying, "He likes the Price bay pony very much."

The horses shipped, Evelyn continued harvesting and selling vegetables with Alec, photographing, and preparing for the next boarder, a Briton named Mr. Colley. Hoping for a clean start with a new boarder, Evelyn "gave bed good dusting with powder" to rid it of bugs.

In mid-September 1894, Ewen and Alec went to Terry to pick up Mr. Colley while Evelyn cooked dinner and finished cleaning. "They arrived at 7. Drove up to porch. Alec introduced me to Mr.

Mr. Colley, their second boarder, and Evelyn's dog Jan pose on the porch. Mr. Colley occupied his time by setting traps and hunting, without much success. He added to Evelyn's knowledge of the elements of photography.

Colley, quite good looking, great contrast to Mr. Adams. Alec very delighted to have Mr. Colley here. He is very fond of him now, wonder if it will last." Evelyn agreed with Alec, soon deciding: "I like Mr. Colley very much."

Before settling into their winter activities, they prepared for their fall hunt into the rough creek country of their 1889 Montana expedition. It took four days to reach the north fork of Cabin Creek, where Ewen wanted to set up their permanent camp next to a spring. They erected a couple of fourteen-by-fourteen-foot tents for shelter, heated by a Sibley stove. "The tents seem very large, much larger than we have ever had before. . . . Pretty good water, but not free from alkali. Saw lots of antelope today. Are up in the badlands now."

Hunting with Alec for an extended period proved a challenge. Mr. Colley held up better than Alec—going out more often—but he wasn't much of a shot, reminiscent of Mr. Adams. "Mr. Colley fired too hurriedly, missing & never saw the lot again." Even Hamlin—their neighbor who had come along to help with the work of camping with two greenhorns—was sometimes off the mark: "Out for walk with all dogs. Met Hamlin coming home. He killed doe & a fawn, & broke leg of another doe. That is the worst of hunting, wounding the game. They must suffer terribly."

After a month of hunting on Cabin Creek, they moved to Cap Rock Shack, anticipating colder temperatures. Mountain rats, or packrats, shared the shack with them, causing Evelyn distress when they stole some food. After they dispatched the rat, Evelyn retrieved the larder, 103 raisins, which she found "quite good, not hurt."

Seeking some privacy, Evelyn and Ewen packed a few essentials and rode back to hunt in the Cabin Creek drainages. First off, they searched for the cabin they'd stayed in five years earlier: "Along top of the divide for about 2 or 3 miles, down through badlands, struck the very head of Cedar creek, went down on the west side of it, finally found our shack. Went inside it, stools & table, good window, open fireplace, been built up since '89 when we were

there with Monty." Even with some shelter from the cabin, it grew so cold and the hunting poor that they returned to their main camp in two days' time.

After six weeks of effort, disheartened by "having these kind of young men to take out," Evelyn and Ewen started for home, riding fifty-five miles in eight hours, abandoning "the boys" to hunt on their own for two weeks. As nearly always, surprise ensued: "Before descending into Fallon Creek, a big she wolf & 4 young ran across our road in front." Stopping at Henry Tusler's to borrow a lantern, coverlets, blankets, and an ax, Ewen learned, "All our chickens were stolen by someone. Great blow!" Examining the chicken coop more carefully, Evelyn suspected it might have been coyotes and skunks responsible for the missing chickens.

Evelyn set to cleaning the house, stable, chicken house, and catching up on mending and laundry. She and Ewen had their home to themselves—no Alec, no boarder—and their days passed peacefully. They read in bed, played hockey on the ice on the creek, visited a new baby in Terry, shod their horses, had good scrubs: "Feel much better after my tubbing last night."

On December 13 they started back to their Cedar Camp with Hamlin driving one of the wagons. They found Mr. Colley and Alec in one piece, but nearly out of food. Hamlin helped Evelyn clean the cabin, then left for home, leaving the Camerons to hunt for another six weeks. As time went on, Alec became more and more disruptive—ensuring this was the last time he was invited on a fall hunt.

Once settled back home in late January, Evelyn began learning the ins and outs of photo taking, developing, printing, and toning, tutored by Mr. Colley. During the river break-up, she, Ewen, and Mr. Colley rode to the Braleys to photograph the Braley girl and her pet antelope: "Mr. Colley took the little buck antelope by itself, & little girl with it (1 year old this spring); Winnie is her name, Dick name of the antelope." Continuing on to Terry to retrieve the mail, they checked on the ice flow: "Down to the river but the

wonderful sight of the enormous blocks of ice floating down is past & the stream has been relieved of its burden. Some large blocks are on the bank stream low. . . . Mr. Colley took [photographed] us on our horses separately & I took Mr. Colley on Andy."

Dissatisfied with their old camera, Ewen began to research alternative models: "Ewen writing to Allen brothers photographers about camera. Ewen wants to get a Kodak which is all done automatically." Their interest piqued Mr. Colley's: "Showed Mr. Colley our camera in detective box. He glanced at catalogue; he wants to buy a Kodak to hold 100 films from Allen (our man)."

Both parties waited a couple of months before ordering their new cameras. In the meantime, Mr. Colley and Evelyn fulfilled photography requests:

> Finally photoed Mr. & Mrs. & 9 month old (today) Miss Furnish. Light got onto one plate, & the other two exposures were failures,

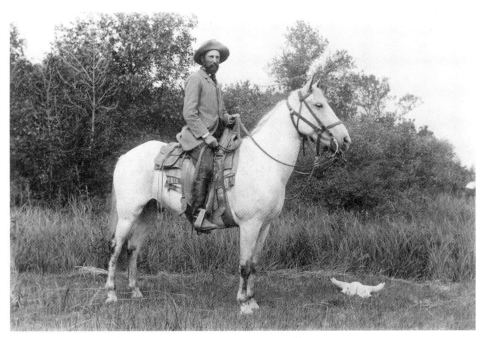

A young and relatively healthy Ewen Cameron on his horse. Like Evelyn, Ewen was a good judge of horses — he just lacked business sense.

there not being a plate in one holder, & the only exposure at all in developing was proved to have been moved by unsteadily holding camera. To get Old Scott took him down to Yellowstone; he arranged himself: old Sharps rifle, belt of cartridges, & revolver, & a silk sash across his shoulder. Medium plates used, put camera on a crate. . . . Mr. Colley helped me all the day.

Evelyn returned five days later to try again:

To Furnishes. After waiting a little took medium plate of Mrs. Furnish & baby & instant one of Mrs., Mr., & child. Took Old Scott down to river, photographed him sitting on a rock & standing on bank near 3 small cottonwood trees. 5 seconds gave each. Up. Sat waiting in Scott's house. Finally took the whole family, . . . Mr. Colley thought I had counted too quickly the 5 seconds.

Because her camera didn't have a reliable shutter, Evelyn had to manually gauge how long to leave the shutter open to let in light. Mr. Colley was right, she had counted too fast: "We went to Mr. Colley's room, Ewen & I & looked at the negatives. 3 very dark dense underexposed. 2 group & Furnishes look clear."

Some of the best images of Evelyn were taken in 1895, when she and Mr. Colley experimented:

Mr. Colley & I hunted for an appropriate place to take our portraits in the shade of the willow near spring, decided to do it tomorrow when the sun was in the right direction. We intensified 2 plates of the ranch in his room, put them in plates under the waterspout, which runs into the spring trough, to wash. . . . Mr. Colley told Ewen morning he didn't like the winter out here & intended going home in the fall.

Perhaps knowing that her time with Mr. Colley was limited, Evelyn took every opportunity to watch him process photographs:

We were to have developed in cellar morning, but I couldn't get around to it. After lunch stuffed up light cracks in cellar wall of kitchen side, stuffed up ventilators. By 4:15 began to work, first cut film off & refitted it. First Mr. Lindsay was developed; unfortunately there are dark streaks across the films of Mr. Lindsay. Must come

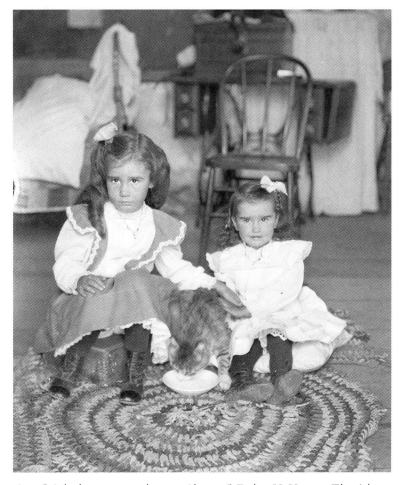

A cat drinks from a saucer between Alma and Esther McMurray. The girls are decked out in their finest: dresses trimmed with lace, petticoats, tights, necklaces, and bows in their hair. The older sister holds the younger sister's hand.

from rather crumpled film, I think. 2 of Old Scott & 1 of hay, loading wagons, latter spoilt by developer spilt on table getting on it when dry.

Later, trying the new toning solution that they had ordered—Eastman's—the prints "turned out beautifully."

In June, Ewen ordered their new camera, a fully manual model, Evelyn's preference winning out. A month later the new camera

arrived: "Unpacked photographic Kodet, Watkins meter, etc." The Watkins meter helped Evelyn gauge the light and time needed for proper exposure. Evelyn packed this camera around for ten years before sending it in for repairs—it was indeed sturdy.

Mr. Colley was the last of their boarders, and within a few more years they'd give up on the polo ponies as well—after a disastrous 1897 shipment where several of them died. From then on they made it on Evelyn's pluck and good sense: cattle ranching, vegetable selling, photography, and the income from her trust fund. Picture-taking, though, was how Evelyn fully expressed herself: her integration—transposed like the shadow of herself in her photographs—into this new place.

— 4 —

A MONTANA PARTING

1899–1900

IF HUNTING TOOK EVELYN AND EWEN TO MONTANA in 1889, another months-long hunting trip, exactly ten years later, propelled them back to England. Whenever they could, Evelyn and Ewen set out on a long hunt each fall to procure enough meat to see them, Alec, and their dogs through the winter. On October 29, 1899, they crossed the Yellowstone River via the ferry and met up with their friends Hamlin and his wife to get a key to Hamlin's dugout, where they'd live for the next three months. Just six miles from the river, the Camerons found the dugout a tight comfortable home. Ewen made an overnight trip to Terry right before freeze-up, returning with the mail, perishables, and oats for the horses. But after Joubert pulled the ferry out in early December, they were pretty much stuck on the north side with the cattlemen, sheepherders, and wolf hunters. It would be January before the ice was thick enough to walk or ride across.

At first Evelyn recorded a peaceful, private time for her and Ewen. She described the geese migration—making a sketch of it in her diary—hunting deer and antelope, and chasing coyotes over hill and dale as they had once chased fox in England. After a few days of tidying up their living quarters and scouting from the dugout, they packed up the wagon and headed deeper into the badlands for a few days, camping near the mouth of Badland Creek "where large cottonwoods abound." While Ewen was out hunting, Evelyn constructed a shelter made of logs and the shell of a cottonwood tree in which to put their bed: "Wagon sheet for a roof, creep under to get in where bed on top of sage brush lay."

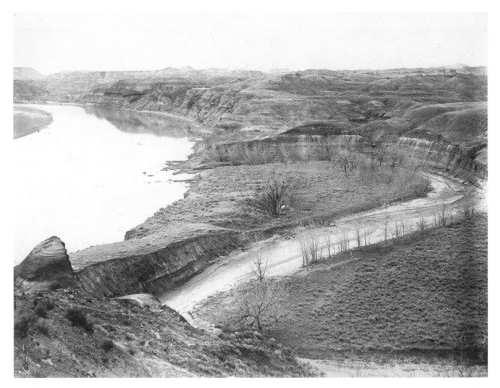

A photo of a road that leads to a ferry crossing on the Yellowstone River. The river was and still is the center of much activity and enjoyment, including fishing, boating, bathing, agate hunting, and bird watching.

Although they soon discovered that their campsite felt damp, the shelter kept them dry.

Every night Evelyn built a big fire and cooked their evening meal, including some version of mutton, beef, or venison. "Fried mutton, potatoes, oatcakes, cocoa." Critters often joined them at dinnertime: "Mice so tame they come & get crumbs just where we sit eating." The bold mice attracted another opportunistic visitor: "An owl sat on a tree close to us in the moonlight after supper."

Their outing stretched into three weeks; Evelyn returned once to the dugout for supplies. After ten days of camping, when she made a trip to the river to wash the beef for stew, she couldn't

resist a dip: "Looked so inviting for a bath although I knew the river was awfully cold, but it surpassed my expectations. . . . I hurriedly soaped myself, but the horrid soap 'White Lily' floats & I had to keep grabbing at it to prevent the stream taking it off. Shook clothes before dressing, so dusty."

One morning, Ewen still in bed and Evelyn pulling on her over socks, their dog Smiler barked at what turned out to be a bighorn ram. Evelyn quieted the dog, then alerted Ewen:

> "Ewen, a mountain sheep, there's a mountain sheep." He did not think I was serious but pulled himself & his rifle out of bed & got the cartridges, took aim, fired. Ram fell, kicking its legs in the air. I said, "What a good shot." But it got up & trotted & walked out of sight & up to top & over divide. Ewen had young trees between him & ram, couldn't get another shot.

For six days the Camerons tracked the wounded ram, finding evidence that Ewen hit it in the intestines. The tracks were easy to follow on the dark gumbo, but difficult on the yellow soil, and nearly impossible when mixed with other sheep. Finally, out of cocoa and temperatures dropping, they packed up and Evelyn led them back to the dugout, hoping to run into the ram from there.

After settling in, Ewen continued his naturalist studies on cottontails, owls, coyotes, and antelope, or Evelyn took day-long photography outings while Ewen stayed behind to write. Always mindful of the weather, Evelyn also noted interesting visual events. One week before the winter solstice, she recounted a moon eclipse on a bitterly cold night: "Moon soon after rising had a slight dark shadow at edge. This developed into a total eclipse but it was not such a dark shadow as I have seen before—like a red-orange coloured piece of tissue paper over it or like some kinds of mother-of-pearl."

Evelyn felt anxious about Ewen during the eclipse because he hadn't returned from hunting and it was twenty-two below zero. The Camerons only had their woolens to keep them warm—

no down or fleece like contemporary people, or skins like the Indians—and they often became cold when they hunted or traveled. Evelyn was putting out a lantern on the roof of the dugout when she heard horse's hoofs. Ewen reported he had shot and cleaned two fawns and wounded a doe out of a bunch of twelve in the Red Hills. Two days later they retrieved the fawns, happy to beat the coyotes to them.

By now, ten years together, and by their standard, married, the Camerons moved with pattern and intent, comfortable with one another. Although they devoted their days to hunting, they still had the chores of caring for their horses and pups, and hauling water and wood. Evelyn had the added responsibility of baking bread and cooking. She often mixed up a stew with their garden vegetables—cabbage, carrots, parsnips—root crops that stored well in the dugout. And as always, she kept up her diary. Having left Alec behind, the Camerons talked more freely. Sometimes Evelyn shared these intimacies. On December 19, Ewen's forty-fifth birthday, she gifted him with a kiss and many happy returns. Another day, buried modestly in an entry, she confided: "We talked much on the subject of having a child. It is my desire to have one some day." Evelyn was thirty-one, almost middle-aged in 1900, yet with undependable birth control, women had babies into their forties.

Sadly, though, it was not to be. Ever since returning from their camp in the badlands, Ewen had been having more and more stomach problems, beginning with what Evelyn called indigestion. While in Terry he had picked up some medicine from Mrs. Gipson and changed his diet. Evelyn doubted the medicine did him any good because the pains persisted. Even though Ewen still went out hunting, Evelyn's entries from early December on read like a medical chart: "Free from indigestion till about 3:30, then began but not very bad. . . . Ewen pain in tum most of the day. . . . About 4:30 another access of pain which lying down relieved."

As most couples do—especially when a problem arises—Evelyn and Ewen talked about their future in terms of where to live and what to do. One night in early December they discussed whether to go back to England or into the cattle business. Realistic about Ewen's stamina, Evelyn reflected: "I don't think him suited to look after a big bunch of cattle."

On January 12 they rode to Terry on horses, likely the first people to try the ice. Evelyn wrote that water stood on the sides of the river, but they found a place to cross by relying on Birney Kempton's estimate that four inches of ice will hold up a horse. They inserted penny wire nails in the shoes of the horses so they didn't fall. The people in Terry expressed surprise the Camerons got across because in places the river was still running the whole breadth. After visiting and picking up their cherished reading material—the mail—they returned with Hamlin, who tested the ice with a crowbar before they crossed back over.

Several days later, when they had planned to go home, Ewen was too sick to ride a horse. For days they waited for word that the ice was thick enough to support a wagon, until Ewen could wait no more:

> Poor Ewen had a terrible night such spasms of pains, flushes & sweats. Turning gave great pain & he tried lying on his back for a long time but could bear it no longer, & after turning dropped asleep for ½ hour. I rubbed his stomac & bowels, which gave only temporary relief. He preferred rubbing to compresses. I arose at 7:30 as I wished to ride & get Hamlin to come with buggy, but when proposed Oudally [Evelyn's pet name for Ewen] was for waiting till tomorrow.

By chance, two men passed that day and Evelyn gave them a note to take to Hamlin. Hamlin arrived at ten the next morning, whereupon Evelyn packed the buggy with the camera, writing materials, bread, and mutton. Hamlin drove the buggy while Evelyn followed: "Wind blew behind buggy & the top was a great

protection. I rode Rocket behind until the river was crossed. . . . Snow, very concerned about Ewen."

The day warmed to sixteen degrees above zero, helping Ewen tolerate the twelve miles. Upon reaching their cabin, Evelyn lit the stoves and brought up the cow and hay to the barn. She prepared Ewen a lunch of mutton broth and rice, then cooked lamb chops, potatoes, and carrots for Hamlin, Alec, and herself. Alec had let the chicks starve so she killed three to stew, but their dog Jan was "well & delighted to see me."

If ever there was a period of trial in Evelyn's life, it occurred during the next five and a half months. She and Ewen grappled with decisions regarding his health. Alec grew more and more obstinate and uncommunicative, disappearing for days to while away his time in Terry. Evelyn not only had the chores but nursed Ewen as well. At first Ewen was so weak he needed help when he bathed: "Gave him a good scrubbing in hot water tub at 3. Ewen felt much more comfortable after it."

Eleven days after they returned home the doctor came from Miles City, some thirty-five miles away, to examine Ewen. Evelyn prepared for his visit by sweeping and dusting and making cakeletts:

> Very smart clean little man. He examined Ewen's stomach & found a place, right ventricle, where he said he could feel a lump but I couldn't & pronounced the complaint as appendicitis at once. He said as soon as well enough Ewen ought to go to Brainerd Hospital, Minnesota, & have an operation, the appendix cut out. Told several stories of men with the complaint, he having performed the operation in Miles, & came prepared to do it here if absolutely necessary. He said Ewen had made a turn for the better & if very very careful about diet would recover but might at anytime have a severe relapse. Left opium tablets. "Codeina."

In 1900 surgery was best avoided. The administering of anesthesia was still an awkward science, and there weren't yet antibiotics if infection occurred afterward—penicillin wasn't developed until

1928. Even so, appendicitis was a worry because so often it was fatal, especially in rural areas. Among Evelyn's clippings is a 1902 article on how the cut is to be made if undergoing appendectomy. The author, a surgeon in Chicago, wrote, "There are few diseases with which more mistakes have been made than with appendicits [sic] & perityphlitis." Because other ailments had similar symptoms, doctors sometimes performed unnecessary surgery. But often the surgery saved the patient's life.

In all likelihood, Ewen's problems were related to something else—possibly food allergies, inflammation or blockage in the digestive tract, or a gastric ulcer. Cancer of the stomach was also more common one hundred years ago because of the way food was preserved. But the Camerons, at least in Montana, didn't eat many preserved foods. Aside from dried fruits, Evelyn and Ewen primarily ate fresh foods and game or lamb. After Ewen became ill, Evelyn was very careful in what she fed him: toast, eggs, mutton, Liebig—a beef broth—foods known to be bland. For breakfast, lunch, and dinner, Evelyn prepared one meal for Ewen and another for herself and Alec.

Ewen was more irritable when he felt poorly, sometimes unfairly blaming his pain on the way Evelyn prepared the food if it upset him. The day after the doctor's visit, Evelyn wrote: "I sat & darned in the darkened sick room while Ewen slept; he awoke at intervals. Felt blue. Read. . . . Rhinos hunt in Africa. At 4:10 Ewen took raw white of an egg but he said I had given it too cold & later he had gripping pains. I felt so unhappy."

Evelyn sent word to Allan, Ewen's brother, and Mrs. Cameron, telling them they'd start for London the end of May to consult with doctors. Alec was more than eager to leave Montana, reportedly to get married. He and Evelyn had several run-ins that spring because he kept making plans to travel ahead of them and didn't have permission from his guardians in England to do so. Although Evelyn doesn't offer an explanation, it appears Alec was assigned

guardians because he was in some way mentally challenged and unable to make good decisions for himself.

The Camerons' lives were chock-full of activity preparing to leave and finishing up work they had begun. They sold things off—their homestead, out buildings, and livestock—and decided what to store in Montana and what to ship to London. Evelyn's photography business thrived because people wanted their portraits taken before she left. Almost every other day she either rode into Terry to take photos or people came to their ranch to pose. One of the more enjoyable sessions involved the three McMurray girls who visited at length, drinking three tumblers apiece of Evelyn's lemonade with wine before the photo shoot in the corn brush, and more lemonade after. Evelyn judged them to be "very nice frank unaffected girls."

The three McMurray sisters taken on June 14, 1900. Evelyn often commented on the photographic conditions: "McMurray (3) girls arrived late. . . . It was very cloudy & wind strong, but brush gave sufficient shelter."

Another time Rebecca McMurray came back alone and Ewen took photographs of Rebecca and Evelyn together. Not often did Evelyn have the opportunity to spend an afternoon with another young woman:

> Rebecca McMurray arrived just as I had finished bath & changed spare room, Dowson divided skirt. Ewen took 5 exposures of us down near old squaw corn patch, separate & together. Difficult, fact impossible, to make horses prick ears. Rebecca McM & I hunted up Roanie [cow] up buffalo draw. Home. Supper 8. Lettuce, first spring onions! Bacon, poached eggs, tea, currants, cold rice pudding. Claret cup all afternoon. She left 8:15, said they would be anxious about her. Gave her the skirt divided Kathleen made me. She rode home in it.

That spring Ewen's improvement was slow because, as Evelyn observed, "Ewen cannot gain strength fast as his inside will let him eat so little at a time." Evelyn's diary entries reveal a condition that never fully healed but could be endured if Ewen took care. If he overdid it: "Ewen not feeling well. He has not recovered from the set back he had from collecting wood to burn." Or, for no reason Evelyn could deduce: "Ewen not so well last 2 or 3 days. Stomach & lower pains now & then."

As the birds returned, so did some of Ewen's strength. On a beautiful March day, the creek running, Ewen went out for a stroll alone. And by mid-April he was up to watching the grouse "dancing," the courtship dance male sharp-tailed grouse perform to entice females to mate. Ewen couldn't dance, but he could find pleasure in being outside and observing his beloved birds. Evelyn, as well, took comfort in seeing the prairie come to life: "A flicker drumming woke me, on the roof or somewhere. Curlews making great noises."

Ewen was especially interested in having Evelyn photograph two juvenile red-tailed hawks. The birds were sitting too high in the tree to knock them out of the nest so Evelyn asked Henry Tusler for help: "Henry did not like climbing in the gale, so he

chopped away & brought it down. Johnnie Van came up riding & gave a few final strokes. Over it groaned & thundered, solid all through. Got the hawks, put in Henry's buggy, they home." That night the nestlings slept quietly with Evelyn in the barn.

The next day they took the hawks out for a photo shoot: "Secured the hawks in a basket (they cannot fly). I took camera & Ewen took hawks. Went to the dead box elder on the creek meadow just to north of ranch. Took four in all, one very pretty one of them on a log in middle distance & the creek full of water winding by."

The hawks didn't learn to fly until shortly before Evelyn and Ewen left for England. Until then, Evelyn hunted cottontails and small birds for them.

Realizing their departure would be later than May, Evelyn had planted a garden. Nearly everyone who came to collect their photos or buy something—from chicks to bed sheets—visited the garden while Evelyn harvested vegetables for them to take home. Sometimes they stopped at the berry bushes, wild currants or cherries, plums or gooseberries, and picked what was ripe. Evelyn moved with such purpose, not writing of her sorrow to be leaving until her cat Chips departed:

> Was sweeping verandah when Mrs Bright & her sister & little Kenneth arrived. Ewen entertained them while I changed "old duds" in darkroom. . . . Went to see hawks. Her [Mrs. Bright's] little chicks changed, three that were roosters for hens. Got Chips by calling & put him in a sack. She is to take care of him till I return to Montana. We sat awhile on the verandah & then to garden. Got them sack of beets & onions. Gathered a few currants that were left, tame. . . . Took poor old Chips away.

The morning they set out for England was a sunny July day, and neighbors came to say adieu. Then they made their way to Terry for more goodbyes before catching the train early the next morning. Evelyn was glad to be on their way, hopeful for Ewen's sake. Little did she know all that would come to pass before she found her way back to Montana.

— 5 —
ACROSS THE ATLANTIC
July 1900

O N JULY 21, 1900, the train pulled out at 5:30 a.m. with their dog Jan relegated to the baggage car amid her rugs, cushions, and water pan, much more comfortable than the poor polo ponies experienced years before. In Mandan, North Dakota, a friend boarded the train "& said the photo album was so much admired he got from me; everyone was anxious to see it." In five short years, Evelyn had become a noted photographer.

Trains moved more slowly in Evelyn's time, but they had fewer stops and delays. It only took three full days from eastern Montana to New York City, including an overnight in Chicago. And a summer train journey could be pleasant. Evelyn wrote that it was "not very hot in the cars nor dusty. Porter dusts everyone off with a wisk brush towards the end of run." And with her fine eye for detail, Evelyn appreciated the scenery: "Pretty country Wisconsin. Wheat, oats, & corn look fine. Everything in first class cultivation. . . . So lovely along the lake Erie & a cool breeze blew in from off the water. . . . Grape fields all along the line." People could identify crops from a train window because in 1900 half of the population farmed or kept gardens.

Evelyn also commented on her fellow passengers: "Swell dressed women got on suffering more from overloaded stomacs than heat, of which they complained (heat) dreadfully. Six officers got on at Sandusky Militia; they drank iced beer & sang songs."

Always conscious of saving money, Evelyn lunched on cookies or fruit along the way, which she purchased from the book agent or at the stops, while Ewen and Alec ate in the dining car or bought

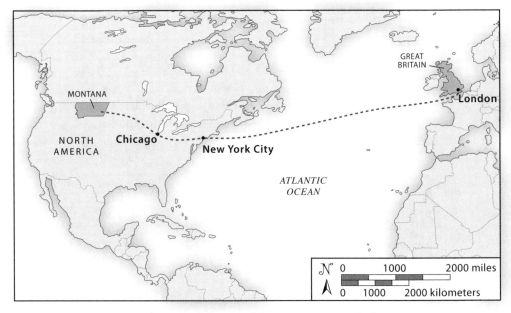

The route of their trip from Montana to England.

sack lunches. At night they retired to sleepers. Each morning, Evelyn cleaned up in the ladies bathroom.

When the Camerons and Alec reached New York City they took a four-wheeled covered buggy pulled by horses to the Broadway Central Hotel. The Broadway was the largest hotel at the time, and more impressively, their room had a bath. First, though, Evelyn went out and bought two waists (shirts), ties, and "a Montana diamond brooch, very pretty one." After bathing she "put on new pink shirt waist" and lunched at the hotel with Ewen. For supper they ate in the dining room: "beautiful roast beef, cauliflower, tatoes, raspberry sherbert, ice cream, etc."

Predictably, of all the activities available in the city, the Camerons chose to visit the zoo: "Tram to Central Park. I bought 6 peaches for 10 cents, ate in park. Saw red deer, Mylgau, fallow, wapiti

[elk], a fine buck of latter in velvet. Very funny to see rhinoceros fed a pail of soaked leaves, carrots, turnips, & apples. She had a baby rhino with her. Opened her mouth very wide for her supper."

Ewen spent their third day in New York resting while Evelyn went out to buy their steamer tickets and check on their freight shipped from Terry. The Terry freight officer, however, had neglected to give Evelyn any receipts so she couldn't transfer her crates. "The stupid," Evelyn wrote in frustration. It would be October before their trunks caught up with them in London.

After four days in the city they were off again in the buggy to the steamer's dock. Evelyn watched as the hold was loaded with corned beef: "Very fine ship, 'Minnehaha.' Maiden trip."

Once aboard, they settled into a sea voyage of eleven days. "Soon cast off & steamed out of harbour. Rather foggy; saw Bartholdi's statue well though." As an Englishwoman, Evelyn referenced the Statue of Liberty by its French sculptor, not its name.

Their days consisted of "sea baths" (bathing in seawater), reading on deck or in the library, checking in on Jan, walking on various decks, attending concerts and Sunday services, plus sharing meals and visits with other passengers. While watching whales Evelyn met an old gent, Mr. Phelps, who was on his fifty-fourth crossing and told her "travelling being different now to what it was 40 years ago." She also met a woman, Mrs. Hoar senior, who had successfully shipped thousands of horses out of America to England and Africa. Evelyn was curious, so Mrs. Hoar took them below deck to see her horses and cattle.

Much like today, the new acquaintances traded photographs. "Mrs. Hoar junior showed me photos of buffalo snapshots, good on Velox. I showed them three of hawks & one Lindsay's rooms [the interior of her good friend Kathleen Lindsay's house]. Very pleased, several wanted to see them." Evelyn made friends with two younger women, playing cards and shuffleboard with them. Having so much responsibility—an ailing husband and a derelict brother—it is easy to forget how youthful Evelyn was.

A ferruginous hawk perched on a tree branch. The Camerons captured and raised many immature hawks for study.

Ewen fared pretty well (no seasickness) except for his exchanges with Alec. In Montana, Ewen and Alec could give one another a wide berth, but on the ship Alec kept up his disrespectful behavior, only now he couldn't wander off to Terry until things blew over. Fed up, Ewen declared he'd have nothing more to do with him, leaving Evelyn to go through "our just cause of indignation with

Alec from beginning to the end. Took an hour." Three days later Alec found Evelyn reading on deck and asked her to forgive him. "I said no, how could he expect me to after his wicked behaviour etc. He went off apparently defiant."

Alec's defiance didn't last a day:

> Into our cabin Alec pounced in on us & after reading a letter from Hamlin all about Alec to his detriment & a talking to from us he utterly broke down & "pray God" & then us to forgive him, not to tell Wickham [Alec's trustee as well as Evelyn's] anything about his behaviour in Montana with us. He was so dreadfully penitent through convulsing sobs we forgave him on the condition he gave up all backsliding concerning us forever, giving a trial of six months.

After a quick jaunt up the Thames River, and sending Alec off on a train to his mother's, Evelyn and Ewen made their way to Mrs. Cameron's flat in Streatham in South London. Evelyn described the reunion as "a quiet but nonetheless joyful meeting. Mrs. Cameron looks very ill but really not older, no wrinkles, hair still black. Front teeth gone but this easily remedied by false when well." It had been ten years since Evelyn had seen her, three for Ewen.

Ewen's Aunt Louisa had written him in June saying his mother was very ill with rheumatic fever, an inflammatory disease that can develop after strep throat. Mrs. Cameron had been a visitor to the men's wards at the local hospital, where she likely came in contact with strep. Rheumatic fever used to be much more common before antibiotics and still is in some countries where health workers are scarce. It often damages the heart, and indeed, Mrs. Cameron died of heart failure nine years later.

The first order of business for Evelyn was applying for a license for her dog Jan so that she could take her off the ship, where she was quarantined. Animals are isolated until there is assurance that they don't carry disease—especially rabies—to a new place. Evelyn and Ewen planned to move to Scotland as soon as they could arrange it; however, Jan had to spend three months in

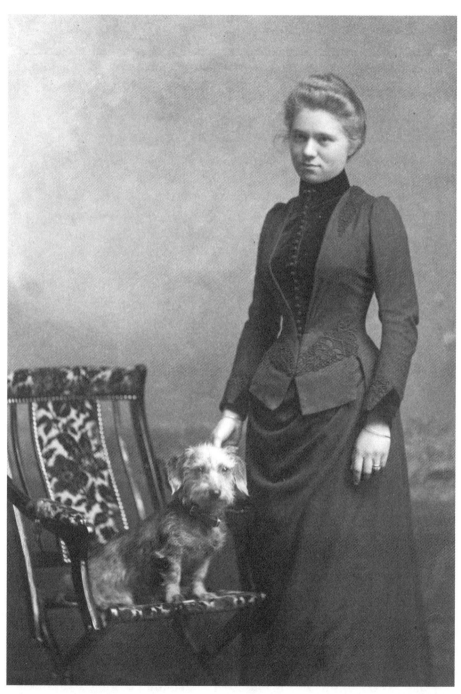

A young Evelyn and Jan, the dog who went to Montana with them. In the early years Jan often got into trouble. Once it took Evelyn over two hours to pull all the porcupine quills out of Jan's mouth and head. Jan did have a good nose, however; she flushed grouse on hunts and found Alec's pipe in the garden for him. Jan loved to chase coyotes. This photo was taken in Scotland, likely before Evelyn and Ewen headed to Montana to live in the Powder River basin in 1891.

England before Scotland accepted her. After it was arranged that Jan could stay with Mrs. Cameron, the license was granted.

As soon as Evelyn arrived in England she had a letter from her mother inviting her to her brother Percy's farm, where her mother lived. Alec wrote advising her, "Says I had better bring evening dress as they all dress. Have none." The only proper dress Evelyn owned she called her Hohner dress—it would have to do. But she purchased a new hat, as well as a new pair of lace boots and gloves. Not surprisingly, given the events surrounding their entanglement, Ewen was not invited to visit. In a rare record of Ewen's affection, Evelyn shared: "He will feel so lonely when I am gone he said, poor old dearie."

Ewen was spared any direct contact, yet even Evelyn worried about how her mother would receive her: "Upstairs met Percy & Mum dressing. Seemed pleased to see me & affectionate. Dressed for dinner." She found her brother Percy much the same but her brother Severin "podgy faced."

Evelyn spent her time on Percy's farm much as she did in Montana: "Fed poor distemper hound pup. Looked at cows, 108. . . . Mare & foal. Fed chicks. . . . We went & ate gooseberries & to the kitchen garden." Except in England, none of it was hers. She also photographed the laborers' cottages, the farm, and arranged a group photo of her family, absent her sister Hilda. And she tried bike riding for the first time: "Seve came & we got Per's bicycle. I got on it. Seve held it for me & supported me round the lawn. Per came & supported other side, but I couldn't go alone." Bicycles had recently become cheaper and safer, therefore more women were learning to ride, granting them added mobility and independence. With bicycles came bloomers, which Evelyn would have easily adapted to, having introduced the divided skirt to her neighbors in Montana.

The morning Evelyn left she and her mother picked a bouquet of mignonette, sweet peas, pink carnations, and marigolds for Mrs. Cameron. Her mother gave Evelyn a photograph of herself

Evelyn went to Percy's farm, the Lea, to visit and took this family photo. Left to right is Severin, Elizabeth (Evelyn's mother), Evelyn, and Percy. Alec lies on the blanket next to the badminton racket.

and "some lace she had worn but very good immitation [sic] [of a finer lace]." As if English was too close, Evelyn wrote the next line in French, relieved that her mother sent her off with a more affectionate farewell than in the past: "Elle disait qu'elle ne croyait par qu'elle pourrait nous visitaet!" [She used to say she did not think how she could visit us!] Percy hoped Evelyn would come back and hunt with him in October, and she responded: "Very kind of him."

Her reunion with Ewen was sweet: "So glad to get me back. Ewen had kept watch for me out of the window part of the evening!"

On August 21—the culmination of an eight-month wait and a trip across a continent and an ocean—Ewen received a letter from Dr. Abercrombie saying he would see him the next day. After busing to the appointment, Evelyn sat in the dining room reading

while the doctor examined Ewen. When the doctor showed them out, he spoke to Evelyn: "Told me meals must be regular & an operation not at present, anyhow the complaint requires watching."

Ewen later gave her a thorough accounting:

> Oudally told me the doctor said appendicitis pain was not where Ewen indicated the seat of his pain was, & the doctor examined him for heart & lung diseases but found these quite sound. Stomac in bad condition, too inflated. He thought this arose from too much sloppy food. Advised game & chicken & to get Brands essences jelly for lunch & extract for beef tea. . . . Said he hadn't a spare ounce of flesh on him, didn't advise sea bathing [swimming] in his present weak state.

Ewen weighed 119 pounds. Seve had weighed Evelyn during her visit to Percy's farm; she weighed 129 pounds and was five feet five inches tall. After a year in England, by the next summer, Ewen had gained thirteen pounds, and Evelyn had lost three.

A tragedy immediately followed this celebrated news of no surgery. On their way down Greyhound Lane, their dog was run over by a dogcart. Heartbroken, Evelyn carried Jan home and buried her under the lime trees in back of the garden. "I felt very cut up. So did dear Oudal." Jan had been with the Camerons for at least ten years—likely since first leaving England in 1891—and was the only pet they had transported from Montana.

Not long afterward, the Camerons encountered a woman who may have been Julia Wheelock (Ewen's first wife). Amused, Evelyn wrote: "Ewen & I on way to Common . . . came upon a lady in a bath chair the living image of Julia. I don't know now whether it was her or not. Ewen says it wasn't although he turned very red." Julia could have been in Streatham in 1900 because in 1901 she moved to Paris to open the Valda-Lamperti School of Singing. Julia had a buxom, full figure, hard to mistake.

As Evelyn often did when she felt blue, she kept busy. She was having trouble finding a dark enough room to develop the photographs she had taken at her brother's farm, eager to share

them with her family. She finally resorted to developing at night, when light didn't leak into the bathroom. She also arranged for some of her finery to be shipped to Streatham from Mrs. Cameron's former home, and set about selling the silver and the plated ware.

Before heading to Scotland—where Ewen's brother and his family awaited them—Evelyn made one more trek alone. She took the train to the seaside resort of Bognor to stay with her sister, Hilda, and to meet her three nieces, who had been born since she moved to Montana: "Got out. Hil came sailing down the platform to meet me, . . . 10 Rock Gardens reached. Children met at door, dear little girls, Joan, Nancy, & Betty."

Evelyn at the seaside at Bognor with her sister (in the chair with the dog), and Hilda's three children, Joan, Nancy, and Betty. One of the children's nurses, plus a family friend and her daughter, accompanied them. Evelyn wrote, "We went & bathed, undressed together in hut, Hil & I, & then we ran some distance into water & had a good swim."

After lunch and a short visit, they all went swimming, including the children's nurses. She and Hil swam for a long while, then Evelyn played with the children: "I made a shack out of sand, for sticks & paper to roof it . . . to amuse children." She also tried bicycling again, determined to learn. "Hil held the bike & I, after a bit, found I could go alone & though I at 1st ran twice into the breakwater & once into a boat, I did very well & could at last turn about & go along the sands."

On Friday evening Hilda's husband, Frank, caught the train down from London, where he worked during the week. Hilda, who married in 1889, had made a more acceptable choice in a husband. Frank managed a tea and provision import business, much like Evelyn and Hilda's father, who had traded for the East India Company, an exploitive British trading enterprise. Evelyn was happy to see Frank. After another morning of swimming followed by lunch in town, Hilda helped Evelyn pack "& gave me a shirt, old one. I wore up to town. . . . Goodbyes to children & nurses. . . . Adios to Frank & old Hil. They wanted me very much to stay till Monday." Evelyn always wrote affectionately about her sister. They seemed as close as sisters could be given the physical distance between them.

Ewen had worked hard on his wolf article while Evelyn was gone. Both he and Mrs. Cameron were steadily improving: "Ewen feeling nary pain, been without it for week about." Maybe it was the change in diet, more fish now that they'd returned to their native island. Whatever it was, it was timely, because they were off to Scotland.

To Ewen's old stomping grounds.

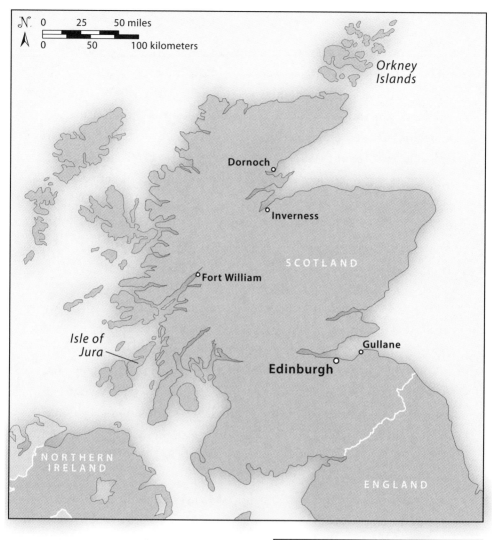

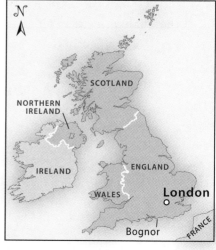

Sites that Evelyn and Ewen visited in Scotland.

— 6 —
A SEASON IN SCOTLAND
September 1900 to July 1901

EVELYN WENT LOOKING FOR A "WATERPROOF" before heading north. She knew autumns in Scotland's highlands drew a chill. She also knew what boys liked: "Bought toy engine & two trucks to pull along. Lifeboat. Soldiers. . . . for Tobe's [Allan's] children." Toys and raingear packed, they took a fast train to Edinburgh, enjoying a lunch of cold boiled chick and Hovis plum bread. From the drawing room of the Douglas Hotel they saw "Princess Street lit up with electric light, many moto cars, more than in London."

Edinburgh dawned lovely so they strolled to a shop where Ewen bought Evelyn a Cameron tartan tie, a wool plaid tie in the colors of the Scottish Cameron clan. The day held another surprise: on the train to Fort William a retired colonel "asked Ewen if he knew Drybrough, had seen his Montana horses." Horses raised on *their* Montana ranch!

Ewen's brother, Allan, met them at the station in Fort William and took them in a horse-drawn carriage to Ashburn House, a beautiful home overlooking the loch that Allan had rented for the winter. Evelyn reported Allan "looking awfully well & brown," an observation that may have pained her in contrast to Ewen.

Following doctor's orders, they renewed their routine of walks and tea and visits and study, all of which was starting to wear on Evelyn. "In & tea. Not hungry a bit here yet. This inert existence is deplorable & depressing." Life picked up some, however, when Allan's wife, Jessie, and the twin boys, Jim and Allan, arrived from a trip. Their only Cameron nephews, the boys had been born one year after Ewen and Evelyn moved to Montana. Evelyn painted

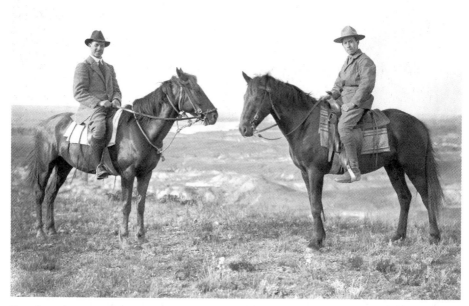

Ewen's nephews, Jim and Allan, came to visit Montana in June of 1912. They were so late in arriving from Seattle that Ewen had decided to alert the Seattle police and cable his brother. The boys, now men, helped out during their visit and came bearing gifts, shirts for Ewen and blouses for Evelyn. A few years later Jim and Allan enlisted in World War I, which they both survived.

this picture: "The arrival was amusing. Tea first claimed their attention, then Allan opened the toys & they were very pleased with them. Jessie looking pale but fatter."

Settled into a boarding house down the street from Allan and Jessie, Evelyn consulted with the cook regarding Ewen's diet. Nearly every day they had tea or lunch—Irish stew, boiled chick, cold pudding pancakes—with Allan's family. Sometimes Allan and Jessie played for them: Allan on the piano, Jessie on the violin. Jessie also played Evelyn's mother's composition "Simple Aveu" on the piano. "Very pretty," Evelyn commented.

Day after day the Camerons delayed their walks because of the weather: shower morning and evening, afternoon very wet,

wet driving rain and wind, afternoon poured and blew. Jessie and Evelyn, who were close to the same age, managed to walk alone together one afternoon, and Jessie "gave me her views on Mrs. Cameron, also the arrival of the twins & a miscarriage before them." After tea one blustery afternoon, Allan stayed to read over Ewen's wolf manuscript. Like his father, Allan was educated at the University of Oxford and seemed to be a more liberated man than Ewen, at least by Evelyn's standards. She noted that Allan "does all the housekeeping."

Finding winter living quarters for themselves and Mrs. Cameron also preoccupied the Camerons. And again, with Ewen having a bad spell, Evelyn bore the burden of responsibility. "Jessie proposes for Ewen to stay here & for me to hunt up a house. . . . Left after tea. Blue." Back in their apartment Ewen agreed, "to my going alone to look at houses at Bonar Bridge, Dornoch, Fortrose, Lairg & he stay here till I return." Over nearly a week Evelyn visited villages and toured houses, meeting innkeepers and widows with space to rent. If a house didn't meet her approval, she wrote "no deal."

Shortly after Evelyn returned from house hunting, they enjoyed their last tea at the Ashburn House. Evelyn presented Jessie with more of her mother's piano compositions, and Jessie gave her a photo of the boys. Then they bid their adieus and headed back to Mrs. Cameron's place in South London. Although Ewen paid Allan and Jessie a short visit the following July, this was a final goodbye for Evelyn. Jessie wrote that they hoped to come to Montana when the boys were in school. A trip to America was still an undertaking, perhaps too ambitious for Jessie. As young men, Jim and Allan did venture west to see their aunt and uncle.

Soon after they settled back at Mrs. Cameron's, Ewen went to see Dr. Barton, who confirmed Dr. Abercrombie's diagnosis: "Thinks Ewen never had appendicitis but peritonitis in the region of the appendix. Does not advise an operation. Careful dieting & Scotch air. . . . Ewen more cheery on leaving; he was nervous before &

thought of course that an operation might be advised." Given what we know now about food intolerances, Ewen may have suffered from an intolerance to gluten or eggs—the two foods he ate when feeling poorly. Evelyn did make a connection between what she called "new" bread and Ewen's stomach problems. Evelyn had a copy of *Mrs. Lincoln's Boston Cook Book*, which cautioned that some people should not eat eggs: "They should be used freely by all except those who *know* [emphasis author's] they cannot digest them."

The other matter to settle before moving north concerned Alec, who kept after them like a sore tooth. Alec had filed a legal action against them, therefore Evelyn had to travel back to Percy's farm to clear it up. Evelyn had an ally in Percy, who had some sway over Alec since he was boarding in Percy's home: "I had to go & hunt Alec up . . . to have a talk with him. He came to my room & I gave him final account with a lecture. Proposed Percy to be told all. . . ." Alec agreed to her terms and signed a receipt rather than reveal to Percy what had gone on in Montana and had happened since. Evelyn found it "a great relief to be through." One evening she showed Percy and her mother some Montana photos, after which her "Mum played" the piano. Upon parting, Evelyn never saw her mother or brothers again. Thankfully, she couldn't have known this.

Evelyn and Ewen decided to rent the Tighnamara house in Dornoch, Scotland. They spent quite a bit of time getting Mrs. Cameron's affairs in order so the three of them could move to Scotland. Already Evelyn and Ewen knew they could never combine households with Mrs. Cameron, which had been one of their options if Ewen's health continued to decline: "Talked unpleasant subject over of Mrs. Cameron's bad managing propensities & extravagance. She trades with two bakers, two green grocers, allows books to run unpaid for months & has no means of checking them! Bills always dropping in; it makes us feel so sick & disgusted." Ewen eventually took his mother to task for her

Mrs. Cameron and her cat, Binny, stand in the doorway of their Dornoch house. Evelyn protested when Mrs. Cameron spent money to buy meat for the cat, who was grossly overfed.

housekeeping, but it fell on Evelyn to arrange a bank advance to pay off Mrs. Cameron's debts.

Although she and Ewen saw eye to eye on Mrs. Cameron, they differed on other business matters: "Business talk, I made Ewen irate. My views are not his." Ever since the early days of the polo pony disaster, Evelyn exhibited more business acumen than Ewen. Shortly before returning to Montana, Evelyn said as much: "Ewen & I confab on future plans. I not very complimentary to him on his management of our affairs & I insist on being allowed at least partly my way in the future."

Finally, after storing Mrs. Cameron's furniture and a trip to see Wickham to secure the bank loan—how often it must have frustrated Evelyn that she had to go to Wickham for access to her own money—they vacated Mrs. Cameron's extravagant household: "Arose 6. Awoke Nellie. I got water onto boil. Made toast. Folded sheets. Screwed down lid box, roped it. Packed Ewen's bag. Men arrive 7:50 & carted all to station, 15 things in all. . . . Mrs. Cameron had Binny [cat] in basket."

After nights in Edinburgh and Inverness, they arrived at their dwelling, the Tighnamara. "Parlour maid came out to receive us. I & Mrs. Cameron partook of a little light refreshment. Men came & put trunks etc. in rightful rooms. Mrs. Cameron very pleased with the house. I felt rather blue. Ewen pains & very exhausted. . . . Extremely nice servants, very pretty cook. Teenie Munro cook & Beatrice Munro table maid, no relation."

The next morning Evelyn went out to order stores and to buy meat at the butcher's: "Meat very dear here, best London prices." Milk and butter came from Mrs. Inglis's farm, the "only clean farm here." And of course Evelyn volunteered to trudge across the fields and collect the milk and cream, and, later in the month, the Christmas turkey.

Dornoch, a village on the sea with a famous golf course—the oldest course in Scotland Evelyn learned—is still known for its good Scotch air and temperate climate. If Ewen was going to

improve, it would be here: "Ewen out without me but by instinct I went to nearest sea; he was there on golf links & we enjoyed the sea & view, very lovely."

To the sea they ventured again on Sunday, where they saw scaup and calloo, a sea duck known for the male's loud musical note. Evelyn returned in time to attend church with Mrs. Cameron at the Dornoch Cathedral: "Beautiful spacious edifice. Good organ & organist & a sing-up choir." That afternoon all three of them walked, Ewen and Evelyn farther onto the sand dunes, taking shelter under some bunkers. The Dornoch Cathedral and butcher shop still exist, as well as a Carnegie library on High Street.

Christmas was simpler in Evelyn's day, much more wholesome. Sending and receiving cards took precedence: "I arrange Xmas cards for Hil's family & Jessie's, 1 for Mum." Evelyn mailed her cards three days early, so they'd arrive on Christmas Eve.

Next of import came food; Evelyn "hunted up Abden gardener & he gave me some thyme & sage, former for stuffing turkey." Their Christmas Eve meal consisted of "hash mutton, vegetables various, boiled potatoes, mince pies, sago pudding, & cocoa." On Christmas Day, Mrs. Cameron wore a "smart black velvet gown" and Evelyn wore her "renovated Grylls evening dress." They— Ewen as well—enjoyed roast turkey, bread sauce, mashed potato, plum pudding, oranges, biscuits, grapes, and Carlsbad plums.

While in Scotland they passed time with walks to the sea, or in the Dornoch woods if it was windy. When it was stormy, as it often was that winter, they read books or magazines lent to them by their new neighbors, and wrote. Ewen could easily spend half a day at his writing table, much as he had in Montana. Their season in Scotland brought Ewen significant literary success: the English journal *Country Life* published an article on the antelope and accepted another on the marsh hawk. The periodical *Land and Water* published both "The Mule Deer in Montana" and the article on wolves: "Ewen's wolf article begun in *Land & Water*, received

this evening. Great rejoicing!" Evelyn's photographs illustrated the mule deer article, but she didn't receive any photo credit.

Despite keeping busy, Evelyn sorely missed her active Montana life. She was discontent to be cooked for and to have no place of her own to shape. On the eve of the New Year, she lamented: "This life is so depressingly tame. I long so to be doing something." A lament that some women still express—their lives restricted by a lack of education, or the society they are born into.

To stave off some of her restlessness Evelyn sketched, painted, and baked bread. And come spring, she began photographing again with renewed passion: the pretty maids; Teenie's house and

Evelyn arranged to photograph their pretty cook, Teenie Munro, and her family: "At 3:15 Teenie &
I sallied out. Quite a step to her house. . . . Very nice cottage, & funny old fireplace so pretty. . . .
Took [photographed] house from barley field. Then groups twice at back, so small piece of shade
difficult to group them." Teenie is third from the left in the light clothing holding the milk pail.

family; Mrs. Inglis's house; Mrs. Cameron and Binny; the postman; Tighnamara; Dornoch; the Sutherlands; the pine woods. Evelyn photographed all and sent prints off as gifts.

As she had in Montana, Evelyn made friends among the locals. She was not only conscientious of how her upbringing set her apart, she had the social grace to bridge that distance. "I got two tickets to the Concert. We are so hard up just now & only go so as not to appear to hold aloof from the residents, especially as Mrs. Hagan is managing it. Is for a new lady's golf club & golf ground, the proceeds."

Evelyn remained cognizant of the gentry in their mix as well, reserving special interest in the Carnegies. Carnegie, a Scotsman who made a fortune in the United States through oil investment and by revolutionizing steel production, helped fund the building of free libraries in the United States and later in Scotland. Early in his life Carnegie was considered a friend to workers. By 1900, however, Evelyn noted this turnabout: "Carnegie builds his own house & free libraries but won't improve crofters houses." By "crofters," Evelyn meant the poor farmers who rented Carnegie's land. Late in May she reported seeing the Carnegies at the cathedral: "Quantity of servants of Carnegie's in church, & Mr. and Mrs., & sweet-faced grey haired lady came in, sat at last row of chairs in their pew. Numerous well-bound books in it."

One beautiful day she and Ewen hiked the four and a half miles to Skibo Castle, the ruins that Andrew Carnegie was restoring for his home. She asked for permission to take photos with the intent of amusing Hilda. She reported on the makeover to her sister: "Very little of the original castle will be left when the new one is finished. A force of 250 men was employed & a piper on the roof playing to them whilst I was there." After more observation, she declared Mr. and Mrs. Carnegie "a devoted couple."

It is hard to remember that Evelyn was only thirty-two while they lived in Scotland. Ewen was in his mid-forties, in precarious health, and quite dependent on Evelyn. He hated to walk alone

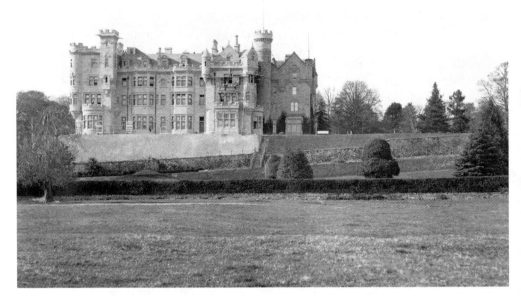

Skibo Castle, Andrew Carnegie's home in progress. Up close there are at least five workmen on scaffolding (not roped in), which is supported by saw horses. Various lengths of wooden ladders are used to reach the scaffolding. The men are turned toward Evelyn. Evelyn wrote, "Skibo built same pink & white stone as this house [Tighnamara]. It is a wonderful pile [large building]."

when she was busy developing and printing photographs: "Ewen loath to go out alone." Yet when they went out together he wasn't always dependable. "I made him mad & he left me. I lay down on the sea & watched waves." Just four days earlier she had written: "We made up our two month coolness."

Most of their arguments were over Alec's slanderous statements against them, or how they managed their money. Evelyn hated to borrow against her inheritance, yet Ewen pressed her to do so. In the end she did sell some of her future interest for cash, and traded other interests to make up annual income. She also contributed 50 pounds a year to Mrs. Cameron. Allan, who seemed to be better off than she and Ewen, said he wouldn't give anything.

One expenditure, however, especially bothered her. Wickham, who was the arbitrator, ruled in favor of Alec in a lawsuit claiming that Evelyn and Ewen owed Alec money dating to their time together in Montana. Evelyn wrote much about what she called the "Alec affair" that winter, and she and Ewen were of the same mind on this one—they had paid Alec all that they owed him. Obviously Alec bore them a grudge and was determined to commit any mischief he could: "Signed deed giving Alec 207 pound mortgage on my reversion through no fault or mismanagement of mine—damn it, say I."

After signing over her mortgage to Alec, she and Ewen went out to play a game of cricket, which they did nearly every day on the golf course. Mostly Ewen won but occasionally Evelyn did. Their team names demonstrated their playfulness: England versus Scotland, or Photographers versus Literary Beggars. "Ewen & I had some good games of cricket, 'Crackle Toasts' v 'Egg Eaters.' Egg Eaters won." They also raced each other, sometimes marking the course beforehand. "Had a 78-yard race, dead heat."

Despite Ewen's displays of immaturity, Evelyn was devoted to him. She attended to him most mornings, shopped and ran errands for him, organized the groceries and cooking based on his needs, read his manuscripts, illustrated his articles, packed his clothes, and arranged his things. He matched her intellectual curiosity—everywhere they go they noted the seabirds—and in the end, he was willing to return to Montana earlier than they had planned.

On June 10 they said their goodbyes and traveled as far as Edinburgh with Mrs. Cameron, where they separated. Mrs. Cameron and Ewen had argued at least weekly all the winter long: "Row Mrs. Cameron & Ewen. . . . Ewen unstrung with these perpetual rows. Mrs. Cameron always airing grievances, although small sometimes, they irritate." Despite the tension, Mrs. Cameron was sorry to lose their company. "Saw Mrs. Cameron off. She was very unhappy leaving Ewen."

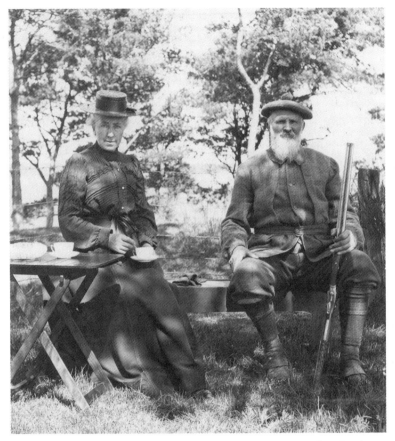

Mr. and Mrs. Inglis owned the farm where the Camerons bought their milk. By the time the Camerons left Dornoch, Evelyn and Mrs. Inglis had become friends. Evelyn described their parting: "She is an old darling. . . . She shed tears at parting. She & I have become quite fond of one another."

Evelyn and Ewen spent a month in Gullane—a town on the south shore of the Firth of Forth. While there, Evelyn's mother attempted to dissuade her from returning to Montana: "Hopes I will not work so hard in America, thinks it wrong for me to do so. If I had 200 pounds says I ought to live in this country easily on it."

When Ewen went to visit his brother one last time, Evelyn "sallied forth" unfettered. She visited the Earl of Weymss castle, neighboring villages, and the seashore, one day covering twenty

miles in boots too tight—Ewen never could have kept up with her. Before leaving Dornoch, Evelyn had heard from a neighbor that the Dornoch people called her "the Walking Lady!" She even bought herself a small bunch of vetches and roses, an extravagance for her.

The evening before Ewen was due back she found a rocky promontory on the east side of the harbour and "watched bathers, very amusing. Everyone into dinner; I ate mine, sardine sandwich, in the rocks, & four oranges." Then she wrote in German, "Ich bin ganst [ganz] glucklichialien,"—I am completely happy. Evelyn was going home.

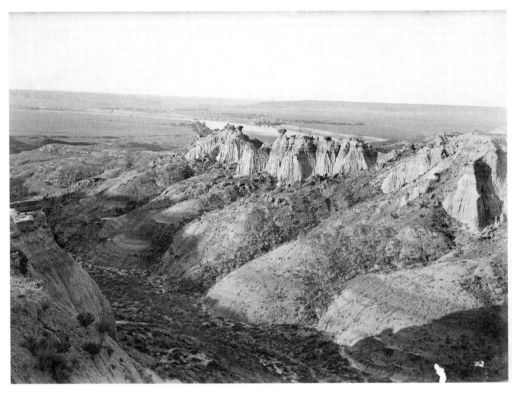

The badlands taken from the north side of the river, near the second Eve Ranch. Custer's Pillar and Panther Rock are included, with the Yellowstone River in the background.

— 7 —
RAMBLINGS IN THE BADLANDS
1901–1907

WITHIN DAYS OF RETURNING FROM ENGLAND—so adept they'd become at making do—the Camerons rented a house near Terry and began the process of looking for land to set up their cattle ranch. In mid-November they took a ten-day "location" trip. Even though it wasn't slated as a hunting trip, Ewen did hunt deer, but with little luck—"Ewen had the buck fever so badly that he shot badly"—while Evelyn poked around:

> I rode to find Montague's spring, went down a draw deep & long into Cottonwood [Creek]. Ate lunch & looked for agates. On down to the mouth were the remains of an old tumbled down shack & barn. . . . Looked over the riverbank, it is just opposite Fallon. Picked up a green glass telegraph thimble shaped affair & took it home. The telegraph first ran through this country this side of the river so the thimble is 25 years or more old.

Mid-week, with the help of a surveyor, they located the last corner to the section they wanted: "I went with Bickle to find NW corner on this No 19 RR section. The springs we know are all on it fortunately."

Nine months later the Camerons secured the purchase and headed to the north side of the Yellowstone River to camp on their land. They spent several days finding all the surveying posts and marking the boundary lines. When the work grew hot, they went to the river to water their horses and bathe: "Bathed. Water clear & very warm at edge of river." While getting a feel for the land, they debated where to build. Ewen advocated for a view; Evelyn leaned toward the practical: "Looked at the high plateau under

hills overlooking the river bottom. Ewen wants to be as high up as possible; I should like a little more shelter & less elevation."

Old-timers weighed in on their choices: "Kempton, on site for us to build, says river rises some years alarmingly high at ice-going periods, & an isle below such as we have [is] dangerous, causing gorges close at hand." And: "Walters came after supper. . . . Gave us good sense talk on river & wells. Confirms Kempton. Thinks river will rise some years 40 feet." They listened to the old-timers, choosing to build below a spring some distance from the river.

Two years later, the spring of 1904 created the very conditions the Camerons were warned of. In a letter to her mother, Evelyn described the break-up:

> We have had a very stormy spring some people aver [maintain] the stormiest ever known here. When the Yellowstone River broke up the ice was piled in great icebergs on both banks interrupting railroad traffic, carrying away trees & fences & endangering ranches. If we had built where it was recommended we should build, all our improvements would have been swept away. Near that place big cottonwoods were cut down & cakes of ice seven or eight feet thick were strewn about.

After the building site was chosen, Evelyn summarized for her mother their land-seeking efforts:

> We have been just one year negotiating for 2 ¼ sections of railroad land (1400 acres). . . . This fall we were able to conclude the purchase for 1 dollar an acre & I am extremely glad because it is a beautiful spot facing due south & abundance of feed, shelter, water & wood. The river is our southern boundary & will supply us with plenty of good fish. . . . Terry will be between eight & ten miles off with the Yellowstone between which, when not frozen (April to December), is crossed by a ferry boat. By crossing the river in a skiff a smaller place than Terry called Fallon is reached about 3 ½ miles distant. The location has all the natural advantages of a good stock ranch.

The next step was to hire a crew to cut logs for the buildings. That done they headed to the Powder River country for a visit with

their British ranching friends. Evelyn had picked out a 400-pound cooking range for Mr. Price, which they packed in the wagon. She fretted about whether she had chosen the right one: "Think it is badly finished off & would like to change for a 'Majestic,' but cannot now. Felt worried about it whole afternoon." Mr. Price seemed happy with her choice, however, and Evelyn proceeded to cook on it while there, writing that it "heated very quickly."

One night while still at Mr. Price's, there was news of a prairie fire:

> I put on an old coat of Mr. Price's & off we all went . . . six miles to fire. Very lovely sight. Looked like lights of a large town, the burning pines. The men put out a little & made burning logs near edge safer. . . . Caton's men, who had a haying camp, started the fire. All their camping outfit was burnt.

Evelyn noted in her diary if there was haze from a prairie fire, especially in late summer. Children were susceptible to fire because people heated with coal and wood and used oil lamps for light. Buried in one diary entry: "Little Putman baby left with three-year-old brother got on fire, abdomen & arm burnt, but would have been killed if the three year old hadn't got water & put it out by standing on a chair."

Leaving Mr. Price's, Evelyn and Ewen rode over to visit their old friends the Dowsons. "Effie came up from her stock chores looking well very, best ever seen her look. Chatted. . . ." Effie and Major Dowson were two of the British community who ranched in the Powder River valley, the first place the Camerons lived in Montana.

After returning home they packed up and moved into a tent on their building site. For the next two months Evelyn prepared three meals a day for themselves and the two or three men who worked for them. Even when she got sick, there was no one to spell her:

> Arose 4:50. Breakfast on. Herb Hamlin milked. Breakfast about 6:20. Pancakes yeast, hot yeast biscuits, minced croquettes, porridge,

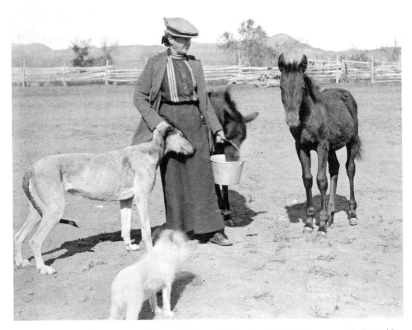

On a visit to the Dowsons' Cross S Ranch, Evelyn "took [photographed] Effie feeding her 2 little 5 or 4 month old ½ hackney colts oats & shorts, with Blue & Flipperts or Flippertina (rough fox terrier)." Effie and Major Dowson were two of the Camerons' closest friends.

bacon, coffee. Washed up. Went out & when I returned the Arbuckle Box cupboard had fallen down & the boxes it rested on also. . . . Stewed beef early. Such a horrid cold, so heavy & my bones ached so. . . . Felt awfully weary.

While Ewen hunted, in her spare time Evelyn helped peel logs and plastered between them. The barn, of course, came first. Herb Hamlin, a Minnesota brother to their old friends the Hamlins, proved skilled at shaping logs with an axe: "Looked at house work. Herb Hamlin is a wonderfully fine hewer. But he does trust to his eye in cutting out to make ends of logs fit too much, & I saw him spoil one log in consequence. Next he measured carefully."

Thanks to her good sense and strong intellect, Evelyn saved the men from a terrible mistake. She noticed that they planned to place the house on a weak foundation and had Ewen call in Herb Hamlin so she could speak with him: "I told him that the loose earth was an impossible foundation he proposed to set the house on. Quite madness to put it there. So arranged to put it against the bank & pantry on west end, leave cellar for spring. Great relief to have settled it."

By late December the Camerons let their workers go, intending to finish the insulating and last bits of carpentry themselves. Two days before Christmas, Evelyn reported: "Dreadful cold wind, *must be* 15 or 20 below. The tent cold. . . . soon drove us out, Ewen to make up heater in house, I to drive cows to water & to barn. Milked. Hayed barn. We looked at room, criticized the work. Amway['s] was noticeable by its 'botched' appearance."

Botched but solid, firmly placing them back in Montana. On December 30 they picked up five more head of cattle at the Hamlins, fulfilling Evelyn's letter to Kathleen Lindsay of two years past that they "intended returning to Montana & go in for cattle, which we found paid very well."

Whether or not cattle paid very well was yet to be determined and evidently on Evelyn's mind. She signed off her 1902 diary on a cautionary note, born of some experience: "Last day of the old year. May the future prove more prosperous, pray I."

Beginning the New Year, not only were they owners of a cattle ranch, their place also suited Ewen's wildlife studies, yet wasn't so far to retrieve their mail from Terry. Hemmed in by the badlands to the east and the river to the south, Ewen had varied habitats in which to study birds. He described the setting thus:

> In 1902, I built a ranch in Dawson County amidst pines four & a half miles to the north of Fallon, on the North Pacific Railroad, & moved over there. The house is situated below some springs

surrounded by pines & cedars where I have placed three water-troughs. All species of birds inhabiting the pine hills of eastern Montana visit them to bathe & drink.

Since arriving in Montana in 1889, Ewen had been collecting data for a comprehensive list of the birds of Custer and Dawson Counties. In 1907–08 he published his observations in three parts in *The Auk,* a well-regarded ornithological journal. During the winters Ewen helped Evelyn move and water cattle, but come spring and summer he concentrated on bird study, hardly earning a mention in Evelyn's diary as to chores completed. In 1904 Ewen returned repeatedly to an eagle's eyrie—which was "situated near the top of a scoriacious [a cindery black crust] rock in the badlands"—to observe developing eaglets. Ewen wrote that the nest, which contained two white, yellow-spotted eggs, was "placed in a hollow niche of the wall face . . . entirely enclosed and sheltered on three sides by a dome of rock."

Evelyn often accompanied Ewen to the nest to chronicle the eagles for an article Ewen was writing. "Started 3:45 for eagles' nest. Grass is growing well & the land looks green. No young, still eggs." Sometimes the weather didn't cooperate: "Rode Toad. Ewen [rode] SJ's to eyrie but too windy to stand on ledge & photo it as intended with my last 4X5. Saw several dead cattle, young all."

Four weeks later she reported: "Ewen been to watch eagles. Young got feathers coming in tail & wings. Old bird sat on rock, & they huddled into the shade made by its shadow." Evelyn went to photograph the changes: "Took one exposure of the eaglettes, feathers coming. Grouse in nest plucked for them." Although the eaglets ate a varied diet, including mountain rat, sharp-tailed grouse and rattlesnakes were the mainstays. On one trip to the eaglets Evelyn "lost a screw from camera & killed a rattler"—an overlooked meal.

Watching out for rattlers came with the territory, and Evelyn killed her share, especially while living on the north side. Scouring

One-month-old eagle chicks with a sharp-tailed grouse in the nest plucked for their snacking. Golden eagles nest in remote places, as this one was. Herders and ranchers alerted Ewen regarding nesting sites.

the gumbo for agates, some of which she sold, Evelyn came close to being bitten:

> Rode Toad to picket outside & with cotton sack & hammer I hunted the hills o'er for agates, most to be found on the barest part of the hills. I suddenly stopped dead within two paces of a silent rattler curled up under a barberry bush. Killed it, when spied another in the same bush. Took both bodies along tied to a string. Skinned both & nailed them out.

At home Evelyn cut the snakes up for her chickens, who "ate with great gusto." That same summer Evelyn's horse Toad was bitten in the chest by a rattlesnake but suffered no ill effects: "A flabby piece of skin on the chest is all the sign Toad shows of his rattlesnake bite."

In a letter to Hilda, Evelyn said she had been doing pretty well with her photography business but "living in the wilds" she did not get as many orders as when they lived near Terry. Even so, hardly a day passed—especially in the summer—when Evelyn wasn't traveling to take pictures, printing, toning, or burnishing (polishing prints). The summer of 1904 she sometimes stayed up till 1 or 2 a.m. to finish an order. Her camera had been used so hard that she needed to send it off for repairs. And she told Hilda she wanted to invest in a more versatile camera:

> When I can afford to invest in a 'Reflex' camera, . . . I shall be equipped to take bucking horses etc. & the photos would go like hot cakes. Times have been so dreadfully hard here however that I have not been able to save my earnings to buy one. I don't care to buy a cheap substitute but want to buy a good one or none.

Evelyn photographed neighboring families, especially the children. She also photographed the Italians working on the second railroad line: "Fair good looking Italians, Michiavelli or 'Mike' & friend 'Guchi'." She worked especially hard to get good results of the cattle crossing the Yellowstone River before being shipped east to the packing plants. Because of the infamous 1904

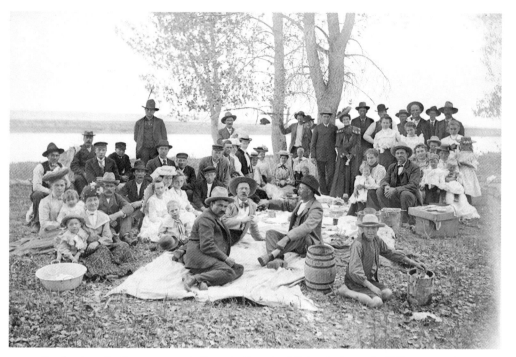

By the time the Camerons arrived at the Fourth of July picnic on the Yellowstone River in 1903, they found the well-groomed group eating. Evelyn noted that every family had brought something to eat. See the barefoot boy churning at the ice cream machine, and one of the men on the blanket is pouring a drink for another man. Ewen is in the back on the far right. Later the party danced on the ferry.

union strike among Chicago's meatpackers, the cattle didn't cross the first time she went to town. Evelyn joked about the strike to Hilda: "It was reported in the papers that two million people in Chicago were forcibly made vegetarians."

A week later, bunked at her friend's house, Evelyn set her alarm clock for 4 a.m., arriving early at the cattle's swimming point. "One lot already across. Waited for the last three lots, 482 swum across. Light [for taking photos] abominable. . . . One punch, to hold herd kept saying, 'Whoa, Dogies, Whoa Dogies'."

That summer Evelyn put together an album for her three nieces, Hilda's children. She'd set herself up at a task and have Ewen

expose the plate: "Ewen took an exposure of me mounting prints at the kitchen table." In a long letter to her niece Betty, who fell out an open window fracturing her thigh and receiving a concussion, Evelyn mentioned the album. She also tried to comfort Betty by sharing broken-bone stories:

> A friend of ours here Major Dowson broke his thigh on a ranch far away from any doctor a few years ago, owing to his horse falling on him. He is now all right, 61, & lively as a cricket. . . . A little nephew who lives in Scotland & is about Joan's age was dropped on some stone steps by his nurse & was very ill with concussion of the brain, but he got quite well again. Of course he was not nearly so unfortunate as you have been. Broken arms, legs, & heads are very common here because the people ride wild horses.

Betty recovered nicely, yet that same month Evelyn received more bad news. Her Cousin Wickham—the cousin who had overseen her trust account the duration of her time in Montana—had died. The news came as a shock; Wickham had seen Evelyn through some hard times and she felt close to him. To Hilda: "I shall miss him very much because he always wrote such kind letters (when he had time) & seemed to take an interest in me."

Living so far from home was hard at times, even for Evelyn, yet the photo albums and letters helped. Whenever she or Ewen published an article, she sent a copy to her brother Percy or to Hilda to be passed around. Ewen did publish his article on the nesting of golden eagles, illustrated by Evelyn's photographs. Although a good writer and an excellent naturalist, having photographs to accompany his manuscripts undoubtedly helped Ewen sell his work, and it is a shame Evelyn didn't receive credit. She did hear from Allan Cameron, though, regarding the quality of her work. Evelyn wrote to her mother that Allan met the editor and photographic superintendent of *Country Life* who "spoke in very flattering terms about my photos & he [Allan] reported their remarks to me, which was of course very gratifying."

Both Evelyn and Ewen wrote for *The Breeder's Gazette*, a Chicago-based agricultural journal. Evelyn published "Sheep in Montana" in the *Gazette* in 1905 using some of the photos she'd taken at sheep ranches. On one outing she traveled twenty-six miles to George Burt's sheep ranch, then trekked back to Terry the next day to retrieve medicine for Burt's ill daughter, Lucille. Finally, she put in a full day of picture taking.

The Camerons' horses, given their hard use, garnered much ink in Evelyn's diaries. Evelyn was adept at appreciating and assessing good horses. On the same visit in which Mr. Price shopped for his cook stove, he gave Evelyn a horse. "Oh! Mr. Price *gave* me a brown pony named Jack that used to belong to Parry. I was

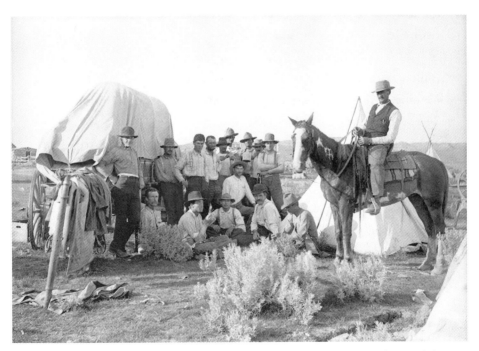

In 1904 Evelyn returned twice to Burt's sheep ranch to take photos because she wasn't happy with her first batch of photographs. Note the teepee-style tents and covered wagon framing this group of shearers. Ewen was always happy to see her return from Burt's ranch, in part because he had all the chores to do while she was gone.

awfully pleased & surprised, half hackney & very well shaped. If not careful will crow hop when you get on — What have I done to deserve it?!"

A skilled equestrian, Evelyn knew how to display a good horse. When Colonel Buchanan arrived from Fort Harrison to look at area horses, Evelyn set out to sell Johan to him: "Showed off Johan on way up. Gallop, trot, canter." Evelyn described the happy result to her mother: "I sold my top saddle mare to Colonel Buchanan, Commanding at Fort Harrison, Helena, Montana, for $130, which is the highest price ever paid for a saddle horse in this part of the country. So you see, I made a record!" Evelyn had only paid $55 for Johan, the usual price for a good horse.

As far as the cattle ranch, Evelyn and Ewen had moderate success and some bad luck. In just one spring they lost calves to birth, a snow bank, a washout, maternal death, and their own coyote trap. Other times, their intervention saved a calf: "To barn. Found Starlight in box where I put her, a head & forefeet appearing. I pulled & pulled. Ewen came & we 2 got it out, attached only by umbilical cord. It would have suffocated if we hadn't drawn it out. The vagina compressed its lungs so."

During the winter of 1903–04 they took sixty-five of Archdale's yearlings and calves to winter on their place because Archdale — one of their British friends — was overstocked. Evelyn wrote to her mother: "This nets us 66 pounds. The work is not so hard as it was because we have now got them in a pasture instead of on the open range where they used to mix up with & stray off with other cattle. As all the open water is frozen up, we have to water 80 head at a pump now, which in itself is no joke!"

Evelyn's empathy for animals extended to the range cattle. In a January letter to Hilda: "This weather, while pleasant for us, is very hard on the range cattle which suffer much from thirst for most of the springs & rivers are frozen. Hundreds may be seen wandering in search of water, bellowing like mad things."

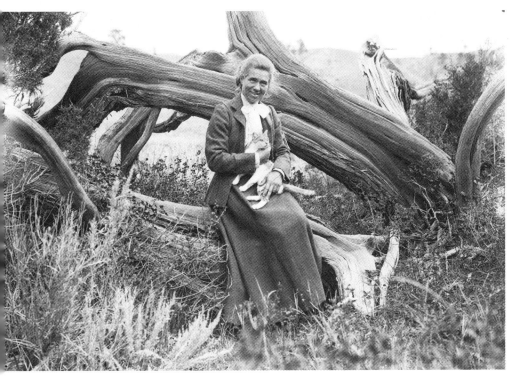

Ewen took this picture of Evelyn and her cat Patchy in what they called the Major's Draw while they lived on the north side of the Yellowstone. Evelyn suspected that Patchy killed their tame sparrow hawk [American kestrel] a few days later.

Despite the good use they'd made of the place, Ewen either grew restless or tired of cattle ranching. In June of 1904, only eighteen months after settling in, he approached their neighbors the Haleys to gauge if they were interested in their place: "Ewen to see Haley. . . . Had dinner at Haleys. Haley will think over buying us out." To hedge his bets, Ewen asked their friend Coil as well. Evelyn didn't want to sell, surely because it was her great effort that created their homes: "*How I do hate to think of leaving.*" Thankfully, neither Haley nor Coil came through: "Told Ewen they [Haleys] could not buy this place, couldn't raise the money. After keeping us on tender hooks all summer."

The Camerons spent two more winters on the north side before finding a buyer. On January 2, 1907, they packed the wagon and with the help of a cowhand moved their cattle across the river to the pine hills near Knowlton, their home of twenty years earlier. Ewen honed in on another eagle's nest, this one at the top of "a tall pine about halfway up a steep hillside," while Evelyn made habitable a deserted farmhouse. Once more they debated—stay or go back to England, the quandary that hounded them.

— 8 —
FRIENDSHIP ON FALLON FLAT
1907–1910

EVELYN AND EWEN ENJOYED nine sweet months in their old hunting grounds along the Powder River. They had dinner with Mr. Price, the Archdales, and other neighbors. Evelyn photographed like mad. Ewen checked in on the eagles, and they cared for their cattle. Not only were they less isolated than on the north side, they seemed to have less work, at least until packing up and moving to their third homestead. In August they took a "ranch hunt" excursion, staying thirteen days at Gipsons' house in Terry and visiting area ranches. "Ewen & I rode out to see C. A. Hackney's ranch above Conlin. Like this ranch better than any I know—within means. Ask $1,100 for it, $100 for hay. Ewen & I looked over it on foot."

They had received $1,600 for their place on the north side, so they had the savings to buy another. As late as May they had discussed whether or not to return to Scotland. Consistently, Ewen seemed to be the driving force behind returning: "Ewen came & we went off to where he had killed a porcupine yesterday. Took it home. Chatted on home subjects. His mother doesn't wish to leave Tunbridge Wells [her new home near London] so how would our return benefit her if we lived in Scotland. She & Ewen never could live amicably together anyhow. Skinned & hung up porcupine. Pulled quills for Mrs. Kempton."

Hackney's acceptance of their offer served as a godsend to Evelyn. Writing to Hilda: "I forgot to add that we made Hackney—the former owner here—an offer without in the least knowing if he would accept, but he did & so we were booked for a longer spell

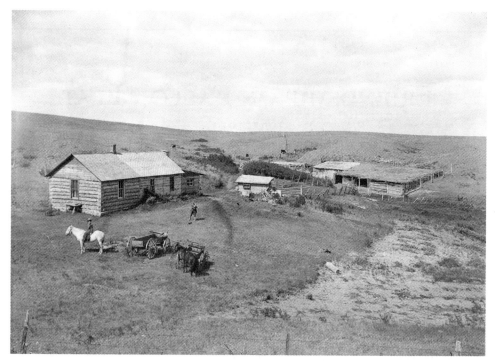

The third and final Eve Ranch, the C. A. Hackney place, with a new room built on. Cattle graze in the background. Janet Williams is on Dolly in the foreground.

of Montana." In another letter she described the setting: "Since taking possession on September 8 I have hardly had time to turn round. . . . We have a splendid kitchen garden & four acres besides under cultivation, which can all be irrigated from a reservoir fed by 4 springs. On this sheet of water migrating ducks come & swim."

The day after taking possession, Evelyn went to drive up the milk cows and found both of them down, foundered by corn — they had found their way into the corn patch and overeaten. It was too much to manage at once, even for Evelyn: "Feel blue about the place being so dilapidated, & cows expected dead."

When depressed, or "blue" as Evelyn called it, Evelyn usually turned to work. This time she risked a technique she'd heard of

from other ranchers—she stuck a knife in the flank of the Jersey cow to release the gas, a technique that can still be effective. "No gas, water poured out." Evelyn had probably gone too deep and hit the stomach. The next day she tried something different on the Guernsey: "Flayed the poor fine milker. Ewen said chance in 1,000 to save her by flank cut, so I cut her & made slit large enough for hand to take out the unmasticated mass of corn & shucks from stomach, but she was too far gone, died afternoon."

Evelyn hated losing her milk cows, especially since they had paid Hackney $50 for each. Less concerned about the money lost, Ewen was "very cross" because there was no butter. Until they retrieved their calves and the other milker from the Archdales, evaporated milk had to do.

Evelyn spent September husking and hauling Indian corn, which she used as feed for their stock. In October she dug potatoes. Sometimes she husked corn from morning to night—when Ewen came to help cut down stalks he moved at a snail's pace. Potato digging also disagreed with Ewen: "Down to dig, I spade, Ewen fork. He pierced many & swore there at!" Frustrated, Ewen tried plowing—which worked: "Ewen got horses, down through garden. . . . Ewen tried it on corn patch first & then potatoes, did a line, then gathered & went over with fork." Their second day of plowing resulted in 800 pounds, and the next, 1,900. According to Evelyn, Ewen plowed "very well."

They stored the corn in the coalhouse, and the potatoes, beets, turnips, and carrots in the cellar. Cellars, which were dug into the cool ground, were essential for storing vegetables in the days before refrigeration: "Dug up about 75 pounds beets & put in root cellar. First cleaned it out. Cellar is well made but water oozes in one end." The potatoes kept well—Evelyn sold 1,000 pounds of potatoes to Hanson, owner of the Fallon general store, and still had 2,500 pounds to sell to neighbors come spring, when most people had run out.

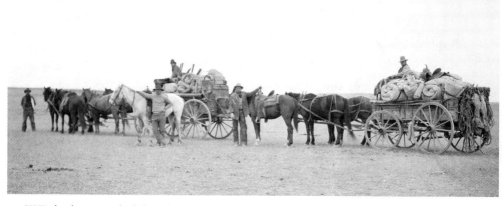

XIT chuck wagons loaded with round-up furniture and supplies on the north side on Bad Route Creek. Round-up wagons needed a good wagon boss and a good cook, which made for a good crew. The cowboys' lives were about to change with the onset of more settlers. Cowboys had such specific skills that the transition proved difficult for many of them.

Two events lent some excitement to their harvest. Their new site sat opposite the cattle crossing of the large XIT ranch, and for four days the cowboys held the cattle on the north side of the river, waiting for available railroad cars. Evelyn didn't stop to photograph the crossing this year, intent on finishing the harvest before the ground froze, but she enjoyed watching the cowboys wrangle their cattle. Evelyn may have regretted not stopping to photograph the cattle crossing because the next summer she heard the "XIT will sell out next year, water taken up, settlers digging, cattle no chance for them to get fat." The Camerons did quit digging turnips to fight a fire: "Fire from RR [railroad]. I had to leave to fight prairie fire."

The fall of 1907 turned out to have exceptional weather, aiding in the harvest. In late October, Evelyn exclaimed, "Glorious day. Never knew such a fall. No frost last night, water not frozen."

And, "Lovely Indian summer continues. No frost last night. Water on chicken pan & up-turned tatoes not frozen."

And Evelyn eventually got the place spruced up, gathering rubbish and burning it in the range. She even mended a skirt Mrs. Hackney had left behind—"Wore brown denim skirt first time de Madame." She was still wearing it a day later when Mrs. Hackney showed up at her door: "Changed. Was wearing her skirt." Nonplussed, Evelyn got dinner on and photographed Mrs. Hackney's children.

The last piece of settling in required another trip to the pine hills to gather and brand the calves they had bought from Ida and Monty Archdale. "Branded our 32 calves EVE with 2 irons, plain bars. Monty did branding, Evans roped & dragged on horse, Lance sat on heads. Mr. Price carried irons from Ewen, who attended the fire. Roast beef & plum pudding for dinner at 12." It took three days to drive their cattle home, the calves plus the five head they

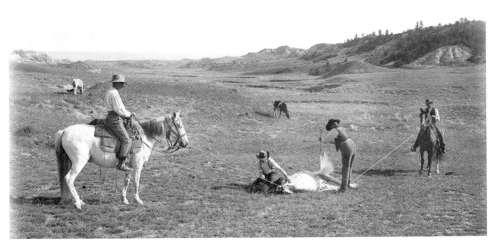

Men branding a horse on the open range, likely in the Knowlton area where the British expatriates ran horses. It looks like Ewen on Dolly on the left.

had boarded at Mr. Price's. These five included their milk cow, Emma — Ewen's butter. After two days of trailing, Evelyn noted, "The old cows went ahead & led well." But the third day, given no chance to graze, the cattle balked: "Hard driving, tired, hungry, had no sticks, only ropes, no good."

Reaching home, Evelyn discovered that "someone slept night in the ranch," not unusual for the open door policy of the plains, which included a bed when visitors dropped in late.

With harvest behind them and the wild calves yet to tame, Evelyn and Ewen settled into their winter routine. Ranch life was never routine, though, and Ewen, who hadn't quite found his footing as a ranchman, had his share of mishaps: "Ewen came in like a drowned rat, having fallen into the reservoir in an effort to open the head gate. Swam a stroke. Hung clothes on line."

On occasion, Evelyn compared notes on livestock with Percy, who still raised cattle in England:

> We are wintering & feeding 37 head of Hereford & Shorthorn calves besides a bunch of older stock. These are a far better class of cattle than anything we have had previously. I believe that one of the young bulls is good enough to win prizes at the fairs round here. We gave the Archdales $16 around for these calves & drove them 60 miles to our new ranch, which we accomplished in three days. We are now breaking the heifers gentle & it is no exaggeration to say they are as wild as deer. One of them has remained on the fight for 17 days, which in my experience is a record.

At Christmastime Evelyn often gave away photographs, a list of which she'd inscribe in the back of her diary. The very last note in her 1907 diary — under "Letters Sent" — read: "December 30, Montagu, John, Photo of Montagu Bute [*sic*] where after a fight he outwitted the Indians." While on a bird outing in the pine hills the summer before Evelyn had discovered the butte Monty fought Indians from. Not only did she photograph the butte for Monty, she apparently named it after him. Monty was their first Montana

friend, the hunting guide who grumbled about tracking bear in deep draws.

A month after mailing Monty a picture of his butte, he was dead. Ewen came to bed late and told Evelyn he "read in *Stockgrowers Journal* that poor old John Montague died of pneumonia in Terry!" *The Terry Tribune* reported: "The last of the old timers or the organizers of the Village of Terry and Terry township has passed away."

Although Evelyn had been too busy harvesting and settling in to mail her usual lot of holiday cards—except for Monty's—she received especially thoughtful presents that Christmas. Her niece Nancy gave her a "dear little album of photos taken by herself." Evelyn wrote and encouraged Nancy's interest, suggesting a composition she might try:

> I received your dear letter & the splendid little photo album, which I was inexpressibly delighted to receive. . . . Your photos are excellent & give such a good idea of scenes in your daily surroundings, which of course are much the most interesting sort of picture. Especially to those who are in a far off land. . . . When you get a chance to take Grandma's photo try to get her looking down ¾ face—Better not focus sharply & she could be knitting one of her sweaters. Don't you think this pose would perhaps have a chance of turning out better than most of her photos?

Evelyn composed loving, adventurous bits of news for her nieces, telling Betty about the wolves they had kept for pets while in the pine hills and spinning a tale for Joan about how the apparently lost fat pincushion Joan had sent was waylaid in New York City. Evelyn doesn't ruminate about not having children—and although exasperated when trying to photograph small children—she obviously enjoyed her nieces and nephews. Also, if someone nearby had a baby, she visited and commented on the baby. In 1908 Evelyn turned forty and had most likely given up on getting pregnant. Ewen was fifty-three, in precarious health, and

cranky, especially when tired: "Ewen very cross—blames me all the time we work together, always."

With Ewen and a ranch to care for, Evelyn likely decided she had all she could handle. The stage was set to embrace a surrogate daughter. Evelyn's first mention of the Williams family was on March 19, 1908, as she hunted for a trail to take her to a shepherd camp: "Found the trail this side of the Williams' shacks & followed in sleigh tracks to the sheep sheds made of ties & willows." Not much more time passed before she decided to walk over "to Williams' shacks on flat. Chatted to both brother [Roy] & sister [Jennie]. Don't want hens." Jennie, or Janet, was twenty-four at the time of their meeting.

Because the Williams didn't want hens, Evelyn commenced to sell them eggs. "I drove first to Williams. Saw Mother for first time, regular middle-aged American type, tall, slight, iron-grey hair, false teeth, pleasant smile. Sold them three dozen eggs, 20c a dozen." Over the next nine months, Evelyn sold one egg shy of 64 dozen to the Williams, which included another sister, Mabel, and the father, Mr. Williams. Next to the Hanson store in Fallon, they became her best customers, outpacing the Italian railroad workers. Christmas of 1908 found the Williams and Camerons having the first of many dinners together:

> Arose 6:20. Breakfast on. Chores. Breakfast 8. I darned stockings. Buttons on Ewen's gaiters. Cut his hair. Dressed. Ewen put on his best buckskin breeches. I, Jessie's dress & cap, black lace scarf over cap, overshoes, socks. Shoes new & 11 eggs, photo of "Advance bunch swimming Yellowstone" in sack. We walked. Ewen very peevish & quarrelsome. I pulled off footgear & put on new shoes 100 yards from house. Came out to meet us, Jennie & Mother. We chatted in sitting room shack. Dinner about 12:30. Sherry coloured soup noodles, roast chicken, sage stuffing, beef roast, mashed tato, turnip, gravy, salad in orange skins, nuts, apples in it, plum pudding sauce, tartlets, soda crackers, maringue on them, nuts. Wonderful homemade sweets, cheese straws, bread

sticks. Played Faust, William Tell, Martha, & sundry duets & solos. Jennie plays very well.

Started home 4:30. Got into old Lund pasture breaks. Ewen very upset. Ewen said if a blizzard came on would perish!! He is always so upset when in a difficulty. Recognized a tree by spring below McNaughton's. Hit road on flat. Home, ½ hour of chores. Supper. W.D. [Wrote diary] Read Bible.

And the last sentence, as if wanting to relish this change in events, Evelyn wrote: "Nice people the Williams. Quite superior." Even after eighteen years on the prairie, Evelyn's proper upbringing shaped her appraisal of people and her appreciation of fine music and food. These sensibilities never left her — changing her overshoes to proper shoes 100 yards out. Evelyn must have felt as if she was back at her brother's farm, listening to her mother when Jennie played.

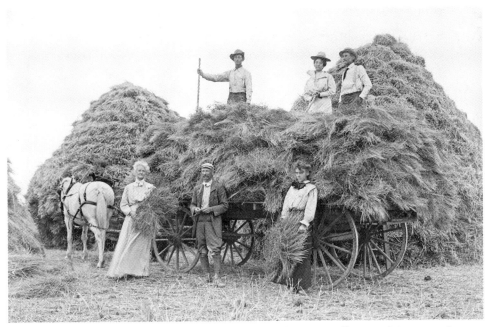

Ewen with the Williams clan in front of their haystacks. Mrs. Williams and Janet stand on either side of Ewen, each holding a sleeve of flax. Roy, Mabel, and Mr. Williams perch on top of the stack in the wagon.

The budding friendship with the Williams was welcome in 1909, a year that brought much grief to Evelyn and Ewen's distant lives. In March, on a snowy day with a north wind, Ewen rode to Fallon for the mail and arrived home at 5:45 with startling news: "Ewen said, 'I got a cable from Tobe [Allan] to say Ma is dead.' Gifford was hitching up to bring it out! . . . Ma left all to Ewen but debts have to be paid! Thought she had none." Even with Evelyn's additional 50 pounds a year, Mrs. Cameron overspent to the end. The next day Evelyn wrote to Ralph Flower [the new manager of her trust] to send 37 pounds to Allan to help with funeral expenses. Neither of her sons attended the internment, with Ewen abroad and Allan ill with influenza.

Two weeks later Ewen received a letter from Allan giving more details: "She had a stroke, & facial paralysis about a fortnight ago & bronchitis supervened. She was always so very plucky & got up after she ought to have remained in bed. Aunt Louisa went down from here & was with her at the end." Mrs. Cameron lived to be seventy-five. She was the only daughter of a British commander and an unnamed East Indian mother. In a letter to her sister-in-law Jessie, Evelyn described Ewen's grief:

> His mother's death was a great shock to Ewen & he worries over it a great deal. . . . For two years Ewen has been very anxious to return & see his mother & at one time had made all his plans to leave so of course he feels very much that now it is too late. We fully realise [sic] what an awful time you & Allan have had & we think it was very good indeed of you . . . to go down & make arrangements for the funeral as Allan was ill. . . . I am sure it will be a good thing for Ewen to get somewhere where he can get fresh fish as he does not eat meat at all now with the exception of chickens.

Evelyn added that they hoped to sell their ranch and come home in July and settle on the east coast of Scotland. "It is possible that we may sell out to some neighbours named Williams who are rather nice people & one of the daughters plays the piano brilliantly. We heard her play last Sunday afternoon & as we have practically

heard no music since hearing you & Allan play duets it produced the effect on us both that there is nothing in the world like music."

Come July, however, Ewen decided to forgo the fresh fish available in England in favor of music and the company of the Williams girls: "Ewen told Jennie he didn't want to sell out now & had told her father so. When Ewen to look out some country alone [Evelyn] told Jennie he was infatuated about them & now content to stay."

On July 11 they celebrated Mabel Williams's twenty-third birthday, for which Evelyn made a chicken pie and put a new ribbon in her belt. They brought a photo album tied with a pink ribbon. Evelyn had written her mother and asked her to send

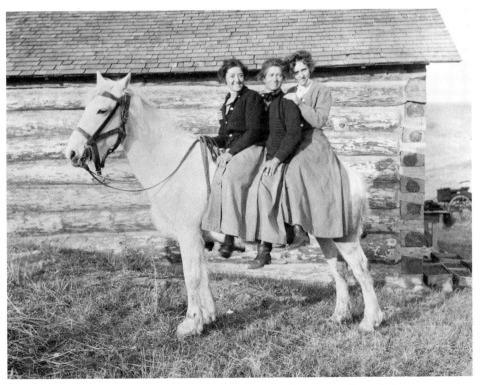

Mabel Williams, Evelyn Cameron, and Janet Williams on Dolly. All three wear the divided riding skirt, probably sewed by Mabel, who was a fine seamstress.

her piano compositions for the girls: "Mum sent Orcades, Ultima Thule & Mikitcat waltzes that she composed." Allan also sent a piece for Jennie to play, and Ewen was "astounded she could play it so well."

The first days of October found the Camerons preparing to drive fourteen steer to the pine hills. Much to their delight, Mabel and Jennie accompanied them. They had trouble finding water fit for humans to drink along the way. Jennie, who wasn't strong to begin with, became ill, probably dehydrated: "Jennie was sick. Mabel stopped with her & last time I did near prairie dog town. She lay & felt disinclined to move. We walked awhile. Mabel & Ewen took the steers on to Archdales. Jennie & I arriving just as Mr. Price had started to look for us."

After delivering their steers, a party of them rode over to Crown W, Mr. Price's ranch. Jennie had things to say about Mr. Price and Evelyn: "Boys [Archdales] went with us. Lionel opened gates. Rode up in couples. After some yelling Mr. Price came out. Jen looked quizzically at me after greeting." That evening Evelyn and Mr. Price made up the beds. When Evelyn said good night to the Williams girls, Jennie said something that unsettled her: "I saw them into bed. Jennie made a peculiar statement!!" Surely Jennie could see that the single Mr. Price was fond of Evelyn. It is not clear if Evelyn realized this even though he had given her many Christmas gifts over the years—a gilt-edged diary, a beautiful leather belt—in addition to the pony he gave her in 1902.

After settling in back home with a new bunch of calves, it was Evelyn's turn to receive sad news. On October 25th she recorded: "Hilda writes Mum not expected to live many days. Just worn out. Dislikes all food & great difficulty in breathing. I went out to haystack for about ½ hour to be alone after reading letter. W.D. [Wrote Diary.] Read Bible."

A week later two workmen brought Evelyn another letter: "A letter from Hil, Mum died Thursday night the 14th at 9 o'clock. So I told Ewen he must go up & tell the girls & their mother not

to come to dinner (as arranged they should) tomorrow to eat the turkey. . . . He went up to Williams & took the turkey for them." Evelyn went ahead and finished her washing, making up three beds, one for the men who had come to build a fence. She ended the entry with "Set alarm for 4. Feel very blue."

Writing to Hilda two weeks later, Evelyn recalled: "It is strange that as our mother once remarked to me—the day you were married—all the important events of her life should have happened in a nine. She was born in 29, married, I believe, in 59, you were married in 89—& so on—& she died at 9 o'clock in 1909." Evelyn must have thought, but not added, "and in 1889 I traveled to Montana with a married man."

Mabel and Jennie walked over to cheer Evelyn up after hearing the news, bringing the breast, leg, and thigh of the roasted turkey, and a tapioca pudding. "Girls arrive 4. Would have been here earlier but Womba, for some unknown reason, pulled back, breaking his rope, fell on his back, dragging Mabel down also. She not hurt."

Ralph Flower quickly passed on information regarding her mother's wishes: "Copy of Mum's will receive yesterday from Ralph. She leaves all she can in moneys to Seve & personal effects to Per." Severin was ill, likely why her mother left him the money. Even though Evelyn's trust from her father's estate was secure, she must have felt slighted to not receive some income from her mother, especially because she now had "death duties," or an inheritance tax on the estate, to pay. Ralph also sent a list of her mother's jewelry to sell to benefit Seve—"Wrote to Ralph & told him I would buy Mum's pearl ring, 5 pounds."

At the end of her diary Evelyn wrote tenderly about her mother: "Painted card by Vicar's wife from Mum. Wishing me a happy birthday. Last ever received from her." Despite her mother's initial displeasure regarding Ewen, she and Evelyn managed a loving correspondence for nearly twenty years.

The Camerons' grief was offset by Jennie's presence, who spent more and more time with Ewen and Evelyn, moving between her

home and theirs. Ewen was teaching Jennie French, and she and Evelyn had grown very close, so close Evelyn signed "Madre" on her letters to both Jennie and Mabel. Although the Camerons did not sell their place in 1909, they developed new plans the next spring, this time including Jennie: "Ewen harangued on plans best to adopt when sold out. . . . go to London [when] fitted out. To Milan for Jennie, Paris–Vienna too expensive."

One spring evening—when Jennie was needed at home because her mother had a lot of sewing to do—Evelyn and Ewen mused while out for a horseback ride: "Perfect evening. We looked at Williams' house & wondered what Jen was doing & wished she could be riding this glorious evening with us. Rode home." Evelyn ended with, "Hope Jennie comes tomorrow."

Evelyn would spend the rest of her life hoping for and looking forward to visits from Jennie.

— 9 —
EWEN'S LAST RIDE
1910–1915

Under the influence of joy I think I could sit up.
—Ewen Cameron, April 30, 1915, 8 a.m.

IN A LETTER TO HILDA IN 1910, Evelyn described the changes taking place in the country, and summarized the Williams family, who were fast becoming an extended family to her and Ewen:

Of course the country has settled up very rapidly and deprived us of range, but, on the other hand, some of the settlers are nice people. One family lives three miles from us & are quite interesting. Their name is Williams, the father is of Welsh descent & the mother Scotch. Two daughters & a son live with them having taken up claims together. The oldest girl Jennie plays the piano beautifully having taken it up as a profession & the younger gal Mabel has studied domestic science & is also a pianist. We have delightful afternoons whenever we visit them. Mum's compositions, Zampa duets, William Tell, Il Trovatore, etc. etc. Zampa always reminds me of you & Miss Ambrose. They ride well & Mabel is a splendid dress maker. They have a brother lawyer in Minneapolis [Warren] who has lately been election manager for the new Mayor who is a highly paid official in America, & this one has a salary of $5000 a year.

Jennie continued to spend a few days each week with the Camerons. She helped Evelyn with the chores—always doing the sweeping after breakfast and baking bread as needed—and practiced her French with Ewen. A typical winter day with Jennie's help read:

Arose 6:30. Breakfast on. Jennie got up & worked up brown, graham & white breads. I swept away snow round door & to barn

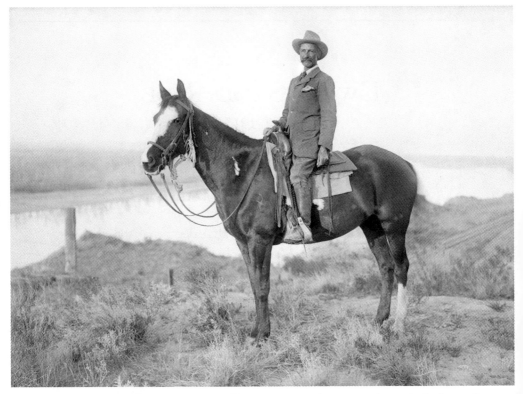

A dapper Ewen on Dazzle with the Yellowstone River and train tracks in the background.
Ewen is fifty-five years old. Mabel and Janet Williams accompanied the Camerons on this
photographic outing.

& fowl house. Fed fowls. Milked. Ewen cleaned barn. Breakfast
9:20—2 poached eggs. Washed up. Swept, Jennie. . . . Baked. Fine
lot of bread, 16 loaves! Dinner 1:30. Chicken. Carrots mashed,
mashed tatoes, onions, jelly lemon, grits pudding. Washed up. Jen
went with Ewen to get horses. . . . Bed 10:30. Jennie & I always
sleep in sitting room on couch drawn out.

After Jennie went home in the morning, Evelyn wrote, "I miss
Janet so much." Jennie's real name was Janet, and Evelyn began
referring to her more as Janet as the years went by. That evening
Ewen, instead of Janet, read to Evelyn, something they did more
of than when they were younger: "Read story of Jack London."

Along with homesteaders came more doctors, and even more importantly, dentists. Toothaches plagued nearly everyone, and settlers, new and established, shared details of their teeth and of promising pain remedies. When Evelyn's teeth bothered her, she usually wrote at the bottom of the page: "Toothache awful." Sometimes she reported treatment options: "Tooth ached, warm whiskey on cotton wool relieved." Or, "Tooth ached terribly after eating. Whisky." Without antibiotics or pain relievers, people — especially in isolated areas — resorted to alcohol to deaden pain.

In 1910 Evelyn and Janet took the train into Glendive to see the dentist. "Washed teeth, to appointment at Baker's. Jen in the chair first. . . . In two hours Jennie through. Baker found my stumps too far gone to crown so pulled. I wouldn't have cocaine. Puss sacks at end of roots!" When Mabel and her father went to the dentist, Mr. Williams lost most of his teeth: "Mr. Williams had 14 teeth (stumps) extracted, has to go back for 3 more to be done." For older people, often too much time had passed to save their teeth.

December of 1910 was chock full of activity, like many past Decembers. The arrival of dentists coincided with that of ice cream, and Evelyn was one of the first to buy an ice cream machine. She and Janet commenced experimenting with recipes, debating whether or not to use part condensed milk or cow's milk only. For Ewen's 56th birthday — which they celebrated on December 18 with the Williams — cow's milk won out: "Janet & Ewen made ice cream, all cow milk & cream & 2 eggs. Used no condensed milk."

With Janet's help the party came off, even though two days earlier Evelyn injured herself by tripping over a rope she'd used to tie up a "willful" cow's leg: "They [Williams] arrived in wagon at 12:20. We finished getting dinner, which ate at 1:25. Turkey, artichokes, mashed carrots, potatoes, gravy, bread sticks, ice cream. Janet made a lovely cornstarch cake for Ewen. Yesterday Mabel made a lovely nut layer cake for Ewen with E. C. in walnuts on it. Everything went off real well."

The next day her pain from her fall worsened—"like a knife stabbing when I moved much," and Evelyn went to bed. Janet stayed on and nursed her while Ewen did all the chores after diagnosing her complaint by referring to their medical texts: "Morning Ewen found by books that I had broken rib. We were glad to find cause of pain." This conclusion came after days of wondering: "My side gives me much pain when I move in certain direction, laugh, cough or clear throat. Wonder what is wrong inside o' there."

Even before Evelyn broke her rib there had been a change in Ewen. Perhaps not wanting to appear less industrious than Evelyn in Janet's view, Ewen had started to pull his weight. "Ewen gets out now & rustles quite a bit of work. I had no barn cleaning," Evelyn wrote late that fall.

After twenty years in the country, Evelyn felt nostalgic about the changes occurring around them: "At chore time coyotes howled so musically. Hope they won't all go in our time." But in the very next entry: "Ewen took rifle as he saw 2 coyotes over by reservoir, but didn't get a shot." Evelyn wanted coyotes close enough to hear them sing, yet far enough not to bother their livestock.

On Christmas Eve Janet and Mabel arrived bearing gifts, with Mabel wearing a skirt she had made from material given to her by the Camerons: "Mabel had her new brown corduroy riding skirt. Looks fine." The girls came to them because Christmas dinner at the Williams was delayed until their flax was harvested: "They threshed yesterday, 20 bushels off Mabel's 25 acres."

Mabel had sewn a black silk blouse for Evelyn, which she wore for the first time to Christmas dinner. While dressing, Evelyn puzzled over the fit:

> Put on black silk shirt waist that Janet gave me for birthday. I buttoned it up in front & thought it looked queer in the glass. Ewen drove me in wagon. . . . All came greeting to the door smiles & jokes. . . . When I took off Jessie's gift coat Mabel said, "Why you have

got the waist on front to back," then we all—Mother, Mabel, Janet, Roy, & I—simply roared for 5 minutes, too too comical.

The Christmas news from Hilda was not as gay as their dinner with the Williams: "Hil's letter very full of interest. Seve is very bad & gets worse. . . . Cannot walk now. Suffers pain, just gets about in rolling chair."

Percy's letter, thankfully, relayed better news. For one, he had married. "Nice little letter, got a place Llanfair, Llandyssul, South Wales, Great Britain, says he has married a Miss Chester of Cheltenham some time ago." Perhaps more of a surprise, Percy had moved to a place where he had land to hunt on and a river to fish in. Percy had to buy an estate on which to hunt and fish, whereas the Camerons and the other citizens of eastern Montana had stream access through public land and cultural permission on private lands.

With the New Year came changes. Mabel had applied for and been selected to teach at the new school opening on Fallon Flat: "Am glad she got the school," Evelyn wrote. "Begins January 1st, $50 per month, 5 months of schooling."

With Mabel employed, Janet felt at loose ends—the Camerons' plan of arranging musical training for Janet had fallen through. They had tried to sell their place all summer, but when Mr. Williams finally found a buyer, Ewen said he was withdrawing the ranch from sale. That meant no trip to Europe. Evelyn agreed regarding their place. She wanted to stay put at least until settling her affairs at home. Still, she understood how much Janet had counted on studying music. Writing to Gertrude Williams, Janet's sister-in-law, Evelyn empathized: "I am afraid that Jennie was disappointed not to go to Europe with us this year, but she never showed it & is always so sweet to me that I get fonder of her every day, if that were possible. She is here now baking bread as I write."

Eventually, Janet shaped her own plans. In September of 1913, Janet declared she wanted "to take a teacher's course in music

Janet Williams at the piano. Two of Evelyn's mother's compositions, Orcades Waltz and Ultima Thule, sit on the music rack. Notice the tennis racket and oil lamp in the background, plus the many portraits.

at Detroit, Michigan. . . . She is full of it & proposes start end of week." Likely Janet couldn't bear to watch Mabel go off again and leave her behind, this time to teach thirty-two fifth graders in Glendive.

After much back and forth: "We chatted in bed. Janet's future — whether to take teacher's course at Detroit, Boston Conservatory of Music, or study with Mr. Scott in Minneapolis been discussed every day. I don't think she is strong enough to take a course East." Janet settled on the Thomas School in Detroit, where Mabel had gone. Thirteen days after declaring her intentions Janet boarded a train, leaving her horse Zip at the Camerons for the winter. The Camerons proposed to help pay for her course: "We to put up $150 now, $100 end October, $100 January, to help pay for normal

school teacher's course, music & drawing. Best plan too I think, she really has her heart set on that work."

Even though Evelyn knew it was for the best, she suffered the pain of letting a child go off to college, underlining in her diary, "*I miss Janet terribly.*"

Although Janet's teachers applauded her progress, Janet gave up the course after two months, writing that it was too hard and she "wished she wasn't so nervous." By late November she had moved to Minneapolis to live with her brother and Gertrude, arranging instruction with a private teacher.

As if missing Janet wasn't hard enough, January brought the first signs of Ewen's imminent demise. Ewen began complaining of headaches, pain in his right eye, biliousness [nausea], and fatigue: "Ewen takes a nap for ½ hour always now, 6 to 7. He gets so sleepy at that time."

In April, Allan wrote diagnosing Ewen's symptoms: "Thinks it is cerebral anoemia [*sic*]" or insufficient circulation in the brain, which could be caused by a brain tumor. Over the next several months Evelyn and Ewen tried natural remedies, such as daily horseback riding and removing butter from Ewen's diet, to bring Ewen relief. By December he was too weak to even chop wood: "Ewen went out 3:30 & chopped wood. He hurt his back yesterday muscles are so weak, but he has to go out to keep biliousness in subjection. . . . Ewen gets a sick feeling every evening at this time, 6:15! Why?"

A few days later Evelyn wrote that Ewen was losing his sight: "Ewen's bad right eye makes him blue & wish he was in London. We think the loss of sight due to overstrain."

By Christmas Day 1914 war had broken out in Europe. In the Christmas mail they learned that Hilda's husband, Frank, was captain of the TW Home Defense Artillery. And Allan wrote that his sons, Jim and Allan, had enlisted in the same regiment. With Ewen too punk to attend Christmas at the Williams, they partook in a quiet Christmas at home. Evelyn was determined to find Ewen another place for the winter, but uprooting had never come easy

for the Camerons. In late January, amid the war news—"Admiral Beatty sunk a German Man-of-War"—they remained undecided: "Ewen not better. We talk going to a warmer climate west for him to improve for 2 months."

Mabel and Janet—who had returned home in April to teach piano on the prairie—continued to bring them joy: Mabel by winning Superintendent of Schools in Dawson County by 76 votes, and Janet with her visits: "Glad to see sweet Janet. . . . She brought us lovely Smyrna figs & oranges & lemons. Chatted with Ewen."

By early February, Evelyn confided: "Evening told Janet I had never seen Ewen so low before without some good reason. Expressed my fear there must be something very seriously wrong."

Evelyn took care of business: writing to Mr. Price concerning their plans, dispersing of their fowl to neighbors, and arranging for their stock to be cared for. With the help of friends Evelyn packed up Ewen and transported him by sleigh to the railroad station in Marsh. There they boarded the train to Butte, then caught another train to Salt Lake City.

At Salt Lake they began their doctor visits, not getting an accurate diagnosis until Evelyn moved Ewen to Pasadena, California, hoping the sea air—reminiscent of his yearned-for Scotland— would restore him. Here they received a diagnosis from a nerve specialist from Los Angeles, which matched Allan's of a year earlier: "brain pressure by abscess or tumour." Evelyn believed that two concussions Ewen suffered when thrown from horses in 1889 and 1897 had caused the tumor.

The days in the bungalow were the hardest of their lives. In a March 30 letter to Allan—when Evelyn believed recovery still possible—she blamed Ewen's decline on his obsession with ornithology:

> We certainly must sell the ranch & make a home somewhere where Ewen has nothing to do but amuse himself. He must not overtax his brain with bird problems. I feel sure that horrid Trumpeter Swan sternum was the means of hurrying on this attack. He thought &

A photo of Ewen and the "horrid trumpeter swan" that Evelyn believed contributed to Ewen's demise. A year before he died, on January 17, 1914, Evelyn wrote, "Ewen very upset, Smithsonian Johnnies [scientists] say the Swan's sternum is that of a Whistler & not Trumpeter as Ewen hoped & believed." The sternum was that of a trumpeter, but it took until May to tease it out.

worried over it night & day until he had those Smithsonian Johnnies on toast, & not until then did he relax.

Although the swan may have taxed Ewen, he had been ill for a long time. Ewen knew he was dying: "Ewen slept for a while, says he is so weak & that he will *flicker out.*"

In the months to come Evelyn exhausted herself caring for Ewen: "Never slept a wink all night & had nervous prostration in my brain. . . . Felt awful, want to sleep so & Ewen so exigent [demanding]." Although Evelyn had never been overtly religious, she did possess faith and when distressed she prayed: "Last night my head felt so bad from brain pressure, I knelt prayed 20 seconds & it left me directly! Direct answer. I felt all right all night though a very strenuous night. Never slept, constant attention." Finally, upon Effie Dowson's insistence, Evelyn hired nurses to relieve her.

Her friend Effie Dowson, the Englishwoman from the Powder River country, had rented a bungalow nearby to help. Effie bought groceries, visited with Ewen, and took Evelyn out for drives in her Buick when a nurse was available to stay with Ewen. In early May — Ewen deteriorating fast and in almost constant pain — the steadfast Dr. Terry was candid with Evelyn: "Dr. Terry says no hope for Ewen, advises me to do just best can to make him comfortable! . . . This is a very distressing life — how will it end?"

And then on May 25, Ewen rallied, as people often do right before dying: "Ewen seemed much better morning, eyes bright and knew me." His knowing brightness was his goodbye — Ewen died at 1:40 p.m.: "I was with him alone at the last. Poor old boy, it was a blessed relief."

Effie, who had seen Evelyn through thick and thin, arrived in her Buick and drove Evelyn to Pasadena to purchase a casket, a plot, and a $5 hat. Evelyn gave permission for a post mortem examination. It took eleven months for Evelyn to receive the report from Dr. Brainerd, and only after Major Dowson intervened. Dr. Brainerd wrote that Ewen died of liver cancer, which had metastasized to the brain.

On May 26, Evelyn and Effie said goodbye to Ewen: "Episcopal service read. . . . Very nice casket. To cemetery, very well arranged. Few prayers. Effie & Mr. Wiley lovely wreaths."

Eager to get home, Evelyn set sail for Portland after cashing the $150 check Mr. Price had sent, knowing she must be short of money. Evelyn heard via the grapevine that Price "Shut himself up 8 a.m. to 8 a.m. when he got wire of news Ewen's death."

True to character, Evelyn started in on her work the day she got home. After checking on the potato plants, she plowed the east and west gardens. June's diary pages record a stream of neighbors and friends who stopped in to see her and hear of Ewen's passing. Thankfully, Evelyn had the hard work of summer ahead and her close friendship with the Williams to comfort her. Even though the Camerons had probably not been lovers for years due to Ewen's poor health, they cared for and appreciated one another as deeply as two humans can. Six days before he died, despite his soiling the bed and certainly smelling of decay, this: "Wrote diary. Bed 8:45. I slept with Ewen." Which to poor old Ewen—afraid of flickering out—must have been the greatest of comforts.

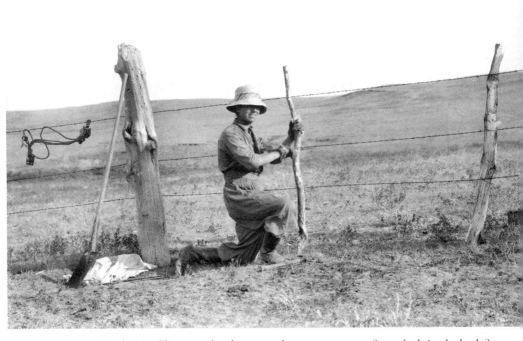

It appears Evelyn is adding another fence post for support or to reduce slack in the barbed wire. She wears bloomers now, no skirt flap, and a newer version of the straw hat. Evelyn owned an interesting assortment of hats.

— 10 —
ON HER OWN
1915–1928

THE MOST DRAMATIC CHANGE IN EVELYN'S LIFE after Ewen's death, other than the loss of his companionship, was that she wrote many more letters, especially in the winter. Her winter chores of feeding and watering her Shorthorn cattle, and caring for her other animals, took about five hours a day. Unless Janet was visiting, Evelyn didn't cook as much, often eating cold cereal for dinner—a favorite being Grape Nuts. Neighbors stopped by weekly to see how she was doing, but her main joy until the end of her life was her visits from Janet. And when Janet wasn't with her, Evelyn wrote to her, sometimes several times a week.

The spring of 1916 Janet and her brother Roy helped Evelyn plow, fertilize, and plant her gardens. Before planting her potatoes she soaked them in formaldehyde—the first time Evelyn recorded doing so—to keep them from rotting. This was a relatively new process suggested by state agricultural stations. All of May Evelyn spread manure on her gardens, giving the hill plants their own dressing: "Made 9 cucumber hills. Carried rotted manure from shed in sack & pail, 2 hauls required for 9 hills, & 1 haul for next 9 to be made tomorrow." She worked alone the next day because Janet had to return to her family in Fallon: "Arose 6. Janet got up 5:40. I stayed in bed. Chores. Watched my sweet Janet disappear over the hill. I do love that dear girl. Cleaned barn, wheeled to raspberries."

Evelyn planted on, forty-eight hills of muskmelon, plus sixty-five of watermelon, dressing each with manure. Eastern Montana's growing season was long enough for melons to ripen, providing a

sweet and nourishing treat in late summer: "Janet dropped melon, beauty. Took it up & we ate it on bench & put t'other in spring box [a box immersed in running water to cool food]."

Evelyn added trees as well that spring, perhaps inspired by Roy, who planted 140 trees over two days with Janet's help. Having gained experience, Janet aided Evelyn in burying six Norway poplars—a fast-growing tree preferred in the northern plains: "Sod so thick I just with pick put it all on one side then dug holes 'large enough to bury a horse.' Put 9 barrows of shed mould [compost] in the holes. At 5:30 we were so hungry that we ate plum cake & drank milk. To work again till 7."

In between the busyness of getting her garden in, Evelyn kept track of the war, especially Great Britain's involvement. Collecting her mail in Marsh she "saw news—Kitchner [*sic*] is drowned

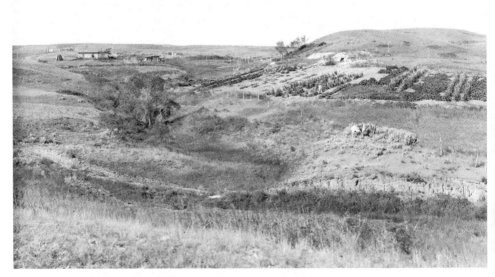

A long view of the final Eve Ranch with Evelyn in the large garden on the right. Her horse Jim is tied to the fence, and a root cellar is dug into the hillside close to the garden.

and staff on *Hampshire*, on his way to Russia!!" Lord Herbert Kitchener was Britain's Secretary of State for War and one of the few to foresee a long war at the onset. It was Kitchener's face that donned recruitment posters in England, helping to organize the largest volunteer army the world had seen.

Reading the papers more closely at home, Evelyn learned that "Kitchener going to Russia at the request of the officials there to help them organize. Torpedo or mine but there were many British mines laid west of Orkneys [Ewen's old stomping grounds]. Seems to have been very careless. 12 men saved on a raft." Today we know it was a German mine, laid by a German submarine, that caused the sinking of the *Hampshire* and the loss of around 650 men.

In July 1916 Janet shared the news that Mabel Williams had a suitor. "Janet arrive over the hill. So glad to see her. We sat & exchanged experiences. . . . Not very good roundup show in Glendive 4th. 3 horses had legs broken & 1 steer killed by jerk of neck. They went up in Sid Souther's car. Mabel & he seem very *epris l'un avec l'autre* [in love with one another]." Janet also recounted a party attended by the young and single where: "They clapped the handcuffs on Mabel & Mr. Sid Souther, electrical engineer and now County Treasurer. They had great fun."

Apparently the handcuffs worked their magic because Mabel was soon engaged. On December 24, Evelyn received a "letter from Mabel asking me to her wedding tomorrow & then they go to Billings for trip. I refused with thanks & congratulations."

The day after Mabel's wedding, Evelyn mused, "Wonder how Mabel is getting along." Although some women advocated for birth control, in those days families weren't as much planned as they happened, as was true for Mabel and Sid. A little over nine months later Mabel gave birth to a baby girl. It didn't take long for Evelyn to plan a trip into Terry to see Mabel and her baby Margaret: "Walked to Mabel's, Janet came running out in green silk waist & striped pretty skirt. Saw baby, fine wee thing, thick

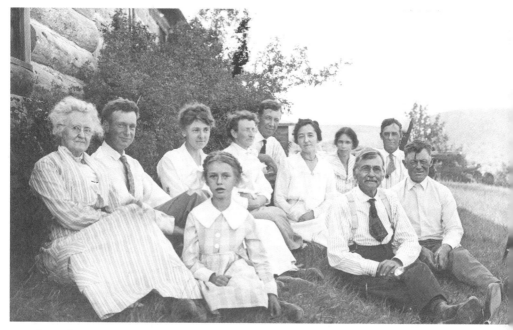

The Williams and Souther families are gathered next to Evelyn's house. From left to right are: Mrs. Williams, Roy Williams, and Janet Williams. Mabel Williams Souther is in the center with her husband, Sidney Souther, at her shoulder. Mr. Williams is in front in the tie. The girl is one of Sid and Mabel's three daughters, likely Margaret, whom Evelyn visits in Terry as a baby.

dark hair, 10# [pounds] when born. Mabel washed it for 2nd time. Nurse Wienlander left yesterday."

Sadder news arrived in a letter from her sister Hilda in late August 1916—Seve had died on July 29: "Poor old Seve dead, buried Aug 2nd, Blockwood Cemetery." Evelyn didn't correspond with her brothers Severin or Alec, so she only knew through Hilda and Percy how Severin was faring. Evelyn felt sorry that he had suffered. When Percy suggested, however, that she help pay off Severin's debts, Evelyn refused. She wrote to Percy:

As regards Seve's creditor Mr. Baker, I think you are super-sensitive in wishing to sacrifice 30 pounds towards reducing the obligation. If Seve had been anxious to meet this gambling debt, for practically it is such, he would have left 1,100 of his 1,350 pounds to

Mr. Baker. I do not feel that I am violating a sisterly duty in refusing to assent to your proposal, and I certainly think you ought not to pay anything either. . . . Ewen's doctor expenses in California were very high & I was obliged to borrow to meet them, & not until this summer could I settle that debt.

Evelyn went on to say that she worked hard for her money, therefore was careful how she spent it:

Ranching is no sinecure [a position producing income without requiring much work]. I work like a Briton—for instance last fall I dug & carried into root cellar two ton of potatoes & marketed them this spring. Last winter I rode 7 miles every day to water by a pump & feed oats & hay to a bunch of 19 head of cattle who ran on wheat & oat straw stacks, besides feeding stock at the ranch. Snow was nearly 2 feet deep for six weeks & tracks always blown full on return trip. I put in an acre of garden this summer which I kept irrigated & entirely free from weeds. I mowed, raked, & pitched 12 ton of hay cut on the ranch alone, with the exception of 2 days when I hired a man to help stack. Last fall I hauled & mined 4 loads of lignite coal, & hauled 3 ton of hard coal from Fallon. Last fall I also hauled 182 bushels of wheat to Fallon from a farm on the flat, which was 9 miles from Fallon.

In her diary Evelyn wrote even more straightforwardly regarding Severin's debt: "He [Percy] proposes we should each pay Stock Exchange friend of Seve's. . . . Yet Seve has left 1,350 pounds absolutely to Hilda!! He ought to have paid the debt with that surely. I won't give a cent to Baker." Currently, when a person dies their debt has to be paid before money is distributed to others, so Evelyn was justified in her thinking—it wasn't her debt to pay.

Gradually Evelyn gained more control of her investments and spending. After she paid off her two railroad sections she didn't have money troubles like she and Ewen had. Right before her death in 1928 she was inquiring about investing in Montana Power stock and still pestering Ralph to hand over all her investments: "I wish you had quoted the clause verbatim under which after my

mother's death her children's estate is to continue under a trust. Perhaps you can in a future letter. . . . Hilda had obtained the control of her capital, why not I?"

Upon her death Evelyn's estate amounted to 7,882 pounds, a testimony to her thrifty and careful money management.

Another object of her letter writing was keeping track of her nephews—the two Camerons and six on the Flower side—who were soldiers in World War I. Jessie Cameron had written in December 1915 giving her an "account of Jim's bravery in the battle of Loos, when the British loss was 60,000. . . . At that time it was said to be the fiercest in the World's history. . . . The military cross he so justly deserved was certainly won at the limit!"

After Ewen's death Evelyn didn't hear from Jessie or Allan as often. In a 1918 letter Evelyn appealed to Jessie to write and send news of Jim and Allan, sharing with Jessie the exploits of her Flower relatives: "Neville's marriage to Mrs. Ponsonly. Frank a major in R.F.A., & Jim, Travers Wing Commander of air squadron. Hilda's account verbatim of air raid she witnessed while staying with Nancy. Joan and Betty nurses." One Flower nephew, John, had been laid up in 1916 from the effects of a "bullet through the head without striking the brain."

Evelyn's dear friend Major Dowson, at 74, wasn't content to sit out the war. Unable to get into the British Corps, Major Dowson managed to get into the French Ambulance Service. He sent Evelyn a photo of himself and his Ambulance Corps, writing, "I am at last satisfied and happy."

The United States didn't enter World War I until April 1917. Early in 1918 Janet traveled to Minneapolis as the chosen representative of the Terry Red Cross Chapter to learn how to make surgical dressings and bandages. Thereafter it became Janet's responsibility to demonstrate technique and raise funds for the Red Cross. "Got mail, long letter from Janet in Terry, very busy with her bandaged dressing demonstrations," Evelyn

reported. Several Sundays in a row Evelyn watched for Janet, but it was soon apparent that Janet was preoccupied: "Thought Janet might come, but no."

While Janet organized the citizens of Terry, Evelyn studied the U.S. Constitution because she had applied for citizenship, although not without misgiving. She wrote to Janet, "Lately I have been memorizing the salient admirable features of your Constitution & Government, hoping to reach the standard which will qualify a capacity worthy of a U.S. citizen, & which must compensate for the sacrifice of my birthright—a British Subject!"

On a Sunday in early April—after gathering Ewen's receipts, making an appointment with the dentist, and borrowing a camera to photograph Margaret—Evelyn took the train to Terry for her court appearance. Janet met her at the depot and they walked to Mabel's. Evelyn found "Margaret very sweet all day." After listening to war talk among the men, Evelyn, Janet, and Mabel went to evening services: "Forsyth minister gave recital on piano & a splendid sermon. Bed 11. Slept with Janet upstairs, did not talk much."

The next day Evelyn had two new crowns put on at the dentist's, then after dinner joined her friend at the local Red Cross effort: "To post office, met Janet upstairs in surgical dressing room, put cap & apron on me & taught me how to make 4 x 4 compresses. 12 at the work. Great fun they seem to have joking. I only made about 6. Some made about 36. 145 altogether made evening."

On April 9, 1918, Evelyn received her naturalization certificate.

> Janet & I to courthouse 9 a.m. Judge Hurley didn't arrive until 10:15 on train. . . . She [Mabel] & Janet sat on either side of me as witnesses in the courtroom, Judge Hurley in his compartment & Mr. Thompson below. Latter asked the questions to witnesses & asked me for dates: 1901 arrived last date, Ewen's death, & if I believe polygamy anarchy. What the Constitution was? What a Republic was & what made the laws? Then let us go. (2 other *Marsh* Germans were turned down.)

The Germans were probably denied due to wartime prejudice. Within two weeks of Evelyn's naturalization, a new order from the Montana Council of Defense restricted German-speaking immigrants' use of their native language. Because the order was unconstitutional, it only lasted for two years.

Later in April, Evelyn returned to Terry for more dental work and to photograph Margaret again, who had reached sixteen pounds: "Took two exposure Margaret au naturelle [naked] & in her chair dressed."

Evelyn photographed the inauguration of the German Lutheran Church in Marsh, on July 25, 1920. An early automobile is part of the frame. Even though it was Sunday, Evelyn rushed home from the dentist in Terry to gather her supplies: "Camera 5 x 7, etc. Onto Marsh. Took exposures. Had to wait till church out 5."

With automobiles in use, visitors were more common, especially in the summer when the roads improved. Even Evelyn was capable of being surprised: "Lay on couch to read 15 minutes when Effie Dowson appeared at the door calmly—'How are you Evie'! . . . Effie very pressing I should go to Santa Barbara run her car for her this winter."

Ever since settling in the West the one community event Evelyn and Ewen participated in was the Fourth of July. In the early years they gathered for picnics, but the celebration could be grand as well, as it was in 1918. Along with Mr. and Mrs. Williams, Evelyn attended several Chautauquas—billed as adult educational events. Some performances she disliked, such as the Rumanian Orchestra; others she enjoyed.

The morning of the Fourth she and Janet attended a "children's circus," and that evening, she, Janet, Mabel, and Sid went to the dance. In the midst of it all was another Red Cross fundraiser. Adding to the excitement, Evelyn accepted a ride home by auto with Mr. Williams, stopping to buy $150 worth of war stamps in Fallon. In her diary she wrote effusively, "Great Day."

Not fully satisfied with her Red Cross work, which she'd exercised to the point of exhaustion, Janet proposed she and Evelyn go to Europe to help in the war effort. Evelyn responded more practically:

> It is futile to think of going to Europe, sweet child, while the war lasts, unless the individual is a professional expert in an occupation useful to the Allies. As you know, the French authorities have returned to their respective countries all those enthusiastic fanatics who have only minor capabilities. . . . Better for you to do a little *less* for your country's welfare & for me to grow food & horsepower for the returning heroes.

Evelyn's good advice may have helped them dodge more than one bullet because the 1918 influenza epidemic—killing primarily the young and healthy—was spreading on the war front in France.

On a vegetable-selling trip to Fallon in mid-October, Evelyn learned of the first local death: "Mrs. Gibson bought pumpkins, 4 cents/pound, 30 cents. She told me *Mrs. Brubaker died yesterday of the new influenza.*"

In another two weeks Evelyn heard, "Everyone got flu Fallon. Mrs. Lund got the worst—pneumonia!" And only a day later, "Mrs. Peterson ran to gate to tell me Mrs. Lund died yesterday of flu pneumonia, funeral today." For some reason pneumonia, a secondary infection of influenza, manifested as especially deadly and virulent in this flu strain, killing people quickly while doctors watched. In Butte, Montana, however, a skillful Chinese physician Dr. Huie Pock was credited with saving people's lives through Chinese medicine.

After Ewen's death, Janet faithfully looked out for Evelyn. During the epidemic she sent Evelyn a gauze flu mask—even though we now know masks are only useful for half an hour or so— which Evelyn began to wear into the Folgers' store in Marsh. As did others: "Garvine masked in store. Folgers wore flue [*sic*] masks."

Evelyn continued the precaution when she went to vote for the first time, riding through sleet to reach her polling place:

> Rode straight to school house 4:30. Put on flu mask before entering. . . . I was 79th to vote; I put my x to the men I voted for. . . . Chat with Mrs. Jake Gifford & to P.O. sent Janet card, "Have just voted—for honor & integrity." . . . Glad I went into vote in spite of disagreeable weather.

After the signing of the armistice ending the war on November 11, Evelyn reported: "Influenza a raging again. Glendive got it under [control], when war peace celebration started again." This was the case in many U.S. cities. When Janet wrote inviting her for Thanksgiving, she said there were "22 flu cases in school house in Terry."

Schools, churches, pool halls, and saloons closed. Especially unnerving was the death of whole families: "Two families been

found dead in their Dakota homes from flu, man, wife, 3 children, near Ismay." It's estimated that nearly 675,000 Americans died of the 1918 influenza, ten times as many Americans as in the war.

Although the flu was letting up, and Janet had been vaccinated, in mid-January Evelyn received a letter that shook her: "Letter from Mrs. Williams saying Janet got bronchitis, for me not to worry, seen her much worse in other attacks. Will let me know if she gets worse. Mabel nursing her. Mrs. Ross might nurse."

Evelyn did worry, making two trips to Terry to see Janet, one with her friend and neighbor Otis, who drove her by car, and the second two days later by train. Janet's bronchitis was better, but she now suffered from stomach inflammation and pain. Evelyn found some bisurated magnesia at a drug store and brought it to Janet, who was limiting her visitors because of nervousness. "Bisurated of Magnesia made her feel much better & more appetite. Her stomach has become very weak & painful. Her diet & aspirins I fear are to blame, & light clothing for her cold which is now gone."

During the flu epidemic excessive dosage of aspirin occurred, especially among young adults who were more willing to try new therapies. There is evidence that over dosage of aspirin in the Navy and Army may have contributed to the severe pulmonary toxicity seen in influenza patients. Once again, Evelyn's good sense saved Janet more misery.

Evelyn's easy affection for Mabel and her baby was disrupted that winter when Mabel's husband, Sid, took a job in Chicago. After Christmas, Evelyn traveled to Terry to see Sid off. "We went to depot, all but Mr. Williams who has beginning of a cold, to see him off to Chicago where he enters the business of Mr. Bates, manager of steel ties & telegraph pole company. If he likes it, Mabel follows in 2 months."

The very next day Montana's prohibition law went into effect, which didn't change Evelyn's life in the least: "Over to Mabel's by 7:15. At 8:15 she to Mrs. opposite [neighbor's home], gathering of

close neighbors for a card & drink party. Men to have a good time in town as town, or rather State, goes dry at 12 midnight. Saloons all a thing of the past."

Montana was one of the first states to ban the manufacture and sale of liquor—the passage likely aided by the women's vote. Montana's women had won suffrage in 1914, six years before the nineteenth amendment guaranteed the vote to all American women.

Late that winter Mabel did follow Sid to Chicago, but the small family returned for visits. A July 1919 excursion out to Evelyn's was especially sweet. Janet and Mr. and Mrs. Williams arrived early to help Evelyn get ready for Mabel's family:

> Arose 7. . . . Chores. Irrigated. Breakfast 9:15. Worked sponge, brown & plum. Tidied house. Mopped evening, quick now the floors are oiled. Made custard pudding, jelly, salad dressing. Baked. Kept a hustling without eating. Made oatmeal cookies. Got lettuce, onions at garden, was washing etc. this in tub when heard hum of a car & here arrives Mr., Mrs. Williams & Janet. Was so delighted. Janet with me to milk when lettuce etc. done. To bed 12. Calm night. Mrs. Williams folded clean cloths.

And the next day: "Lovely cake from Mabel & when Mabel & Mr. Souther arrived 1 p.m. they brought ice cream contributed by Janet. . . . All enjoyed negatives. Photos, 6 exposures outside."

Evelyn's negative collection suffered a blow in 1917, when negatives for the first seven years of photographs—taken between 1894 and 1900—ended up lost in the British mail. When Evelyn and Ewen parted from Mrs. Cameron in 1901, a trunk of Montana negatives was accidentally left behind. Until 1917 Evelyn had paid for them to be stored, at which time she asked the company to mail them to Hilda. Nine months later Hilda wrote saying the trunk had never arrived. In a letter to the storage company, Messers W. Brackett & Sons, Evelyn asked of their whereabouts, stressing: "The photographic negatives are of great value *& I would not accept 20 pounds a piece for most of them,* for they represent western scenes in

U.S.A. which can never be duplicated, now that the prairies have been turned over by the plough." (Thankfully, prints for some of these negatives survived the past century in family photo albums.)

Whenever possible, Evelyn continued to advance the ornithological work she and Ewen had compiled. In December of 1917 she received a request from a Smithsonian scientist asking for Ewen's notes on the trumpeter swan. Evelyn sent notes of the whistling swan by mistake. Embarrassed by her error she apologized to Mr. Bent:

Feb 5th Tuesday, My dear Mr. Bent,

I received your letter of January 16th yesterday and regret exceedingly having made such a *stupid* mistake in sending you my husband's data on the Whistling swans & thereby wasting much valuable time & patience.

By this mail I am sending all the material collected by my husband on the Trumpeter swan in III Parts. I believe this was fully corrected and ready for the typewriter. . . .

I took great interest in my husband's hobby and he illustrated his articles with my photos; in fact, I may say, that our ornithological rambles were our greatest pleasure in life. Really I am so very sorry to have disappointed you and sincerely hope the notes, I am now sending, will contain good material for your ornithological work.

Believe me, very truly yours, EJC

These notes were of the very swan that Evelyn believed depleted Ewen of his remaining energy. Nonetheless, Evelyn was proud of Ewen's ornithological accomplishments. She shared with her cousin Ralph Flower what Dr. C. Hart Merriam, head of the Biological Survey, eulogized about Ewen: "What a pity it is for such an able man, & such a good & useful citizen to be stricken in the prime of life! His contribution to the Ornithology of Montana will remain a monument to his memory."

Although less dramatic, Evelyn's passing was just as untimely as Ewen's. Her last year of life was much like other years: she fed the

Williams clan; she anticipated and enjoyed visits from Janet, who retired from her courthouse duties thereby allowing her to drive out to Evelyn's ranch more often; she appreciated that which was new: "I was behind barn getting weeds when a fine large aeroplane sailed or rather flew 500 feet right over me, so low!!"; and she cared with a practiced know-how for her plants and animals — *"Deer track going north over garden."*

In late June she and Janet took the train to Miles City on a shopping excursion, much like modern-day friends. Then again in November to Glendive, with Mattie, Roy's wife, to find a new coat for Janet: "Janet tried on numerous coats in 3 shops & finally bought very nice dark blue English freeze cloth with raccoon long fur collar, $110."

Aside from the normal aging process — napping more frequently and having others do some of the heavier work such as chopping wood — Evelyn gave no indication of slowing down. She still hauled hay, fed and cared for her stock, and grew a large garden. Yet Evelyn was bothered by what she called appendix pain, although some of it was obviously a pinched nerve, or sciatica. Evelyn had written to Hilda about what she called lumbago pain for years, which by her description was sciatica. She wrote in her diary about wanting to have her appendix out, even outlining the preferred anesthesia: "Do not use Ether, Northern Pacific Hospital, Glendive, but use Ethelyn, does not make patients so rigid, muscles more relaxed."

All her life Evelyn had worried about appendicitis, as did many others who lived far from a doctor or hospital. Alongside horse accidents, appendicitis seemed to be the primary health concern of the rural population because it came on suddenly and was life-threatening. On December 19, 1928, two days after enjoying a salmon dinner and *"Mrs. Williams' mince pie, dee-licious,"* with Mattie and Janet, Evelyn took the train to Glendive. There she phoned the Northern Pacific Hospital for an "operation appointment." According to a letter written by her surgeon to Hilda, Evelyn

had high blood pressure and hardened arteries, causing him to delay surgery for a day. Sadly, Evelyn died from heart failure the fourth day after the appendectomy—an operation she probably didn't need.

Prior to making the trip to Glendive for surgery, Evelyn sent her Christmas orders and letters. To Hilda, a "photo of Janet and me car" plus a subscription to the *Saturday Evening Post*, but "did not mention appendix plans." To J. H. Price, the book *My Life as an Explorer* by Sven Hedin. To Mabel, a photo of the ranch and $10. To Jessie and Allan, a ranch photo and *The Literary Digest*. She did tell Mrs. Folger, whom she supplied eggs to, of her appendix plans, and of course, Janet, whom she also sent a Montgomery Ward's package for Christmas.

Poignantly, at the back of Evelyn's 1928 diary, she had written in pencil on an address page: "Father—Phillip [*sic*] Flower; Mother—Elizabeth Jephson; August 26—age 60 years." Yet how well she lived those sixty years. Evelyn wrote in her diary that Janet's brother once had this to say about her: "Mr. Ed Williams amusing, said been in nearly every state but never seen a woman like me. I said you didn't see all the women." Nonetheless, Mr. Williams gave a good assessment of Evelyn.

And that's the gist of it. Evelyn is what each of us is capable of being, and what many women and men in eastern Montana remember their mothers and grandmothers as having been. She expressed herself artistically and behaved with confidence, integrity, and honor. And she loved well: Ewen, Janet, Mabel and the Williams clan, the Dowsons, J. H. Price, her English relations, all manner of creature, and always, this good and giving earth.

How Photography with
Glass Plates Works

Evelyn Cameron's first serious camera was a No. 5 Folding Kodet, which was manufactured by the Eastman Kodak Company from 1895 to 1897. Made of mahogany wood covered with leather, the camera looks a bit like an accordion. It was listed at $22. A photographic image was imprinted on a pre-manufactured glass photographic plate—five by seven inches in size for this camera model. The glass photographic plates used by Evelyn are stored at the Montana Historical Society.

In the 1870s—twenty years before Evelyn began taking pictures in Montana—a dry glass plate negative process was developed by Richard L. Maddox. This negative process was easier to use than the existing wet glass plates, in part because the exposure times were shorter. Also, the dry plates were pre-coated and did not have to be prepared with liquid emulsion at the site where the photograph was taken. This was a considerable advantage, saving time and equipment.

View cameras like the No. 5 Kodet were set up for image framing and focusing before the film holders were inserted. Therefore, after setting up the tripod and screwing the camera onto it, Evelyn framed and focused the image she wanted. Next she slid a plate encased in a holder into a mount on the back of her camera. A camera gasket sealed around the holder. Evelyn then pulled the dark slide—the moveable inside cover—off the plate. The light, or image, she allowed in while the shutter was open imprinted on the light-sensitive gelatin emulsion fixed to the glass plate base. Thus Evelyn recorded the image inside the dark camera cavity.

Evelyn slid the cover back into place, preserving the image. Then she removed the glass plate, now enclosed in the holder. She took the plate back home where she developed a photograph from the image in her makeshift darkroom.

Evelyn recorded the exposure times in her diary or next to the photographs in her albums. For example, she wrote, "Bright sun. ½ second." This means she exposed the negative for a half second because the sun was bright at that time of day. Two days earlier she used an exposure time twice as long because the sun was going down: "Clear. Sun low. 1 second." The right exposure time produced the best prints, not too light or too dark, and with a good amount of detail and contrast.

Glass plates are still used by fine art photographers who want exceptional detail and a broad tonal range in their prints.

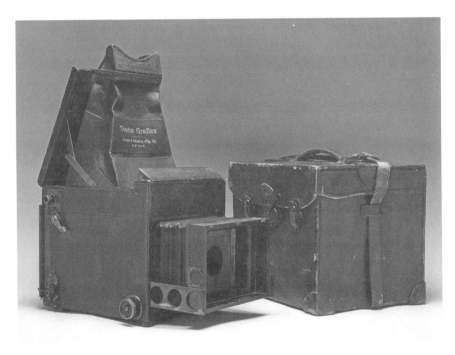

Single lens reflex camera purchased by Evelyn Cameron in 1905, thereafter becoming her primary camera. —Montana Historical Society Collection, 1991.07.01

CHRONOLOGY OF EVENTS

1829, December 24, Elizabeth Lee Jephson born in Camberwell London, England (Evelyn's mother)

1834, January 4, Mary Colebrook Traill born in India (Ewen's mother, Mrs. Cameron)

1854, December 19, Ewen Somerled Cameron born, first son of the Reverend Allan Gordon Cameron and his wife, Mary

1856, June 13, Allan Gordon Cameron born, second son of the Reverend Allan Gordon Cameron and his wife, Mary; attended Trinity College, Oxford

1862, May 20, Homestead Act passes U.S. Congress; immigrants, freed slaves, women, all qualify for 160 acres

1865, Civil War ends

1866, First cattle drive into Montana

1867, February 10, Alexander (Alec) Jephson Flower born

1868, August 26, Evelyn Jephson Flower born in Streatham, London

1871, November 10, Reverend Allan Gordon Cameron dies (Ewen's father)

1872, February 14, Philip William Flower dies (Evelyn's father)

1872, Montana Territory passes a bill protecting wildlife by a closed season, February 1 to August 15; protected animals include mountain buffalo, moose, elk, black-tailed deer, white-tailed deer, white Rocky Mountain goat, mountain sheep, antelope, hare, songbirds, and fish

1876, George Armstrong Custer and his men die at Battle of the Little Bighorn

1881, January 15, Ewen Somerled Cameron marries Julie A. Wheelock (Madame Giulia Valda) in Nice, France

1882, Age 14, Evelyn begins keeping a diary although those prior to 1893 are unaccounted for

1883, August 15, Janet May Williams born

1883, Northern Pacific Railroad crosses Montana. Had reached Montana's eastern boundary in 1881; by 1882 up the Yellowstone

Valley and into the mountains; by fall of 1883 reached Garrison, where it joined with Utah Northern

1883, Bison decimated

1885, August 20, Allan Cameron and Jessie Campbell marry

1886, July 11, Mabel Ross Williams born (Janet's sister)

1886, Rush of money and livestock to eastern Montana reaches its peak, grasslands overstocked with cattle and sheep

1886–1887, Severe winter kills thousands of livestock in western United States

1887, March 16, Sidney A. Souther born (Mabel Williams's husband)

1887, Percy Jephson Flower (Evelyn's brother) on Orkney Islands hunting with Ewen

1889, Montana achieves statehood

1889, January 5 to January 21, Evelyn likely visiting Ewen at Mrs. Cameron's home. We know this because on February 22, 1893, Evelyn writes to Mr. George Roberts, "Dear Sir—I have referred to my diary of 1889 and I find that I was at Tunbridge Wells from Jan. 5 until Jan. 21." Evelyn was responding to an inquiry regarding an order for corsets that was likely her sister Hilda's order.

1889, February, Severin Jephson Flower (Evelyn's brother) marries

1889, May, action for annulment of Ewen's marriage commences

1889, June 6, Hilda Jephson Flower (Evelyn's sister) and Frank Aston Edwards marry

1889, September 14, Evelyn Flower and Madame Valda listed on *Teutonic* passenger list, Arrival date: 12 Sept. 1889 (Ewen Cameron likely posed as Madame Valda)

1889, September, Camerons make their way to eastern Montana and Missouri Breaks; Evelyn 21, Ewen 34, no evidence of marriage, not possible until Ewen divorced from Julia

1889, October 17, Julia receives annulment from Ewen, claimed impotence

1889, November 1, Evelyn writes in 1894 diary, in red, "This day, in the year '89, we started on our first hunting trip."

1890, Non-native population of Montana 143,000, mostly in western valleys and mining cities of Butte and Helena

1891, September 22, Ewen and Evelyn Cameron and Alec Flower (Evelyn's brother) arrive in New York City

1891, Rent a ranch on Powder River, called 4.4., east of Miles City; pine-covered hills and river views ("45 miles from anywhere," Evelyn wrote her mother-in-law)

1892, August 21, Allan and Jessie Cameron's twins born, James and Allan

1893, Evelyn's existing diaries begin

1893–1900, Evelyn and Ewen rent three-room log cabin with stone foundation from Henry Tusler and call it Eve Ranch. Cabin is six miles south of Terry, only ten years old, near creek for drinking water and thicket of fruit trees and chokecherries and rose brush, one-acre kitchen garden, included a wooden verandah nearly seven feet wide.

1895, Creation of Game and Fish Commission in Montana

1895, 1896, 1897, ship polo ponies from Terry to T. B. Drybrough in England

1898, Camerons buy small herd of cattle

1900, July 21, Ewen, Evelyn, and Alec leave Terry, Montana, travel back to England

1900, December, Ewen, Evelyn, and Mrs. Cameron move to Dornoch, Scotland, for winter

1901, September 3, Ewen and Evelyn arrive in Montana; left Alec in England

1902, Fall, build Second Eve Ranch on north side of Fallon, north of the Yellowstone River; buy 1,354 acres for $1 per acre from Northern Pacific Railroad

1906, Alec Flower marries a Belgian woman

1907, January 2, leave second ranch and rent house near Knowlton for winter and summer 1907

1907, September 8, move to Third Eve Ranch on south side of the river near Fallon Flat; view of Yellowstone River; Northern Pacific Railroad runs through; four springs and a reservoir

1907, Fall, Janet, Roy, and Mabel Williams stake homesteading claims near Fallon, neighbors to Camerons

1908, February 4, Camerons' friend John W. Montague (Monty) dies, scout of General Custer, born Oct. 30, 1837

1909, March 10, Mary Colebrook Traill Cameron (Ewen's mother) dies, 75 years old

1909, October 14, Elizabeth Lee Jephson Flower (Evelyn's mother) dies

1909, Enlarged Homestead Act passes Congress; Ewen files for 320 acres

1914, August 4, United Kingdom declares war on the German Empire

1915, May 25, Ewen Somerled Cameron dies in Pasadena, California; buried there, 60 years old

1915, June 4, Evelyn returns to Eve Ranch from California

1916, July 29, Severin Jephson Flower dies (Evelyn's brother)

1916, November 13, Evelyn buys another 40 acres at $3.55 an acre; $142 total

1916, December 25, Mabel Williams and Sidney Souther marry

1917, April 6, United States declares war against Germany

1917, October 8, Margaret Souther born to Mabel and Sidney

1918, April 9, Evelyn becomes a naturalized citizen of the United States

1921, First hunting law passes; makes it unlawful to hunt any game animal without a license

1928, December 26, Evelyn dies in Glendive of heart failure following an operation for appendicitis, 60 years old; siblings Percy, Alex, and Hilda still alive; bequeaths her property to Janet Williams

1929, January 8, Allan Gordon Cameron dies (Ewen's brother)

1978, Time-Life Books editor Donna Lucey learns about collection of historic photos stored in basement of ninety-five-year-old Janet Williams in Terry, Montana

1991, *Photographing Montana 1894–1928: The Life and Work of Evelyn Cameron*, by Donna Lucey published

2001, Evelyn Cameron inducted into the National Cowgirl Hall of Fame

2011, April 16, Evelyn Cameron inducted into the Gallery of Outstanding Montanans

FAMILY TREE OF EVELYN JEPHSON FLOWER (CAMERON)

Philip William Flower and Elizabeth Lee Jephson

Elizabeth Jephson Flower*
1860–1863

Severin Jephson Flower
1861–1916
married in 1889

Alexina Jephson Flower*
1861–1863

Ella (Ethel) Jephson Flower*
1862–1863

Percy Jephson Flower
1863–1939
married in 1903 to
Esther Ada Chester
had at least two children

Percy Cecil

Hilda Jephson Flower
1865–1950
married on June 6, 1889
to Frank Aston Edwards

Nancy Betty Joan

Alexander Jephson Flower
1867–1930
married in 1906

Evelyn Jephson Flower
1868–1828
marriage partnership, 1889
to Ewen Somerled Cameron

Lionel Jephson Flower
1870–1875

*Three of the children died in the fall of 1863, probably from an epidemic of typhoid or scarlet fever, both contagious bacterial diseases.
The early "birth dates" may be christening dates.

FAMILY TREE OF EWEN SOMERLED CAMERON

Allan Gordon Cameron and Mary Colebrook Traill

Ewen Somerled Cameron
1854–1915
married in 1881 to
Julia Wheelock,
divorced October 1889;
marriage partnership, 1889
to Evelyn Jephson Flower

Allan Gordon Cameron
1856–1929
married in 1885 to
Jesse Campbell

Jim Allan

Mary Colebrook Cameron
1859–1878

WILLIAMS CLAN

Owen Rowland Williams and Margaret Ross Williams
1847–1926 1848–1943

Roy R. Williams
1878–1930
married August 16, 1924
to Phoebe Mathea Olsen

Warren O. Williams
estimated 1881 birth,
according to the
1940 U.S. Census

Mabel Ross Williams
1886–1974
married December 25, 1916
to Sidney A. Souther

Margaret* Janet Claire

Edgar T. Williams
no dates available

Janet May Williams
1883–1982
never married

*Margaret was born October 8, 1917 (part of the book)

BIBLIOGRAPHY

My primary sources are Evelyn's diaries, spanning thirty-five years, which are archived at the Montana Historical Research Center. I kept the British lexicon whenever it was clear, spelled out most abbreviations, and corrected very few misspellings. After the diaries were scanned, reading them became much easier because I could enlarge the type and make out Evelyn's meaning, a distinct advantage in later research.

I used many informational and historical articles, too many to list, to give context to the time in which the Camerons lived. Also, Donna Lucey's biography on Evelyn, *Photographing Montana*, served not only as a secondary source but as fine inspiration.

Aadland, Dan. *Women and Warriors of the Plains: The Pioneer Photography of Julia E. Tuell*. Missoula: Mountain Press Publishing Company, 2000.

Alwin, John A. *Eastern Montana: A Portrait of the Land and Its People*. Helena: *Montana Magazine*, Inc., 1982.

Armstrong, Henry L. *The Camerons—Evelyn and Ewen: Birding in Central Montana 1912–1913*. Geraldine; Henry L. Armstrong, 2002.

Battersea, Constance. *Reminiscences*. London: Macmillan and Company, 1923.

Bernardin, Susan, Melody Graulich, Lisa MacFarlane, and Nicole Tonkovich. *Trading Gazes: Euro-American Women Photographers and Native North Americans, 1880–1940*. New Brunswick, New Jersey and London: Rutgers University Press, 2003.

Blodgett, Harriet. *Centuries of Female Days: Englishwomen's Private Diaries*. New Brunswick: Rutgers University Press, 1988.

Cameron, Evelyn J. "The 'Cowgirl' in Montana," *Country Life*, June 6, 1914.

———. "Jealousy in a Turkey Tom." *Country Life*, November 22, 1911.

———. "The Prong-horn as a Pet," *Country Life*, January 16, 1909.

———. "Ranch Pets in the Northwest." *The Breeder's Gazette*, December 4, 1907.

———. "Sheep in Montana," *The Breeder's Gazette*, vol. xlvii, no. 13, March 29, 1905.

Cameron, Ewen S. "The Birds of Custer and Dawson Counties, Montana," *The Auk*, vol. xxiv, no. 3, July 1907.

———. "The Birds of Custer and Dawson Counties, Montana," *The Auk*, vol. xxiv, no. 4, October 1907.

———. "The Birds of Custer and Dawson Counties, Montana," *The Auk*, vol. xxv, no. 1, January 1908.

———. "Changes of Plumage in *Buteo Swainsoni*," *The Auk*, vol. xxv, no. 4, October 1908.

———. "The Ferruginous Rough-Leg, *Archibuteo Ferrugineus* in Montana," *The Auk*, vol. xxxi, no. 2, April 1914.

———. "Nesting of the Golden Eagle in Montana," *The Auk*, vol. xxii, no. 2, April 1905.

———. "Nesting of the Great Blue Heron in Montana," *The Auk*, vol. xxiii, no. 3, July 1906.

———. "Notes on the Swainson's Hawk (*Buteo Swainsoni*) in Montana," *The Auk*, vol. xxx, no. 2, April 1913.

———. "Notes on the Swainson's Hawk (*Buteo Swainsoni*) in Montana," *The Auk*, vol. xxx, no. 3, July 1913.

———. "Observations on the Golden Eagle in Montana," *The Auk*, vol. xxv, no. 3, July 1908.

———. "The Puma in Montana," *The Field*, January 19, 1895.

———. "The Puma in Montana," *The Field*, February 2, 1895.

———. "Sheep and Coyotes in Montana," unpublished manuscript.

———. "Sport in the Badlands of Montana U.S.A.," unpublished manuscript.

———. "A Trip After Bear in the Missouri Brakes, Montana." *The Field*, no. 1,999, April 18, 1891

———. "A Trip After Bear in the Missouri Brakes, Montana." *The Field*, no. 2,000, April 25, 1891.

———. "A Trip After Bear in the Missouri Brakes, Montana." *The Field*, no. 2,001, May 2, 1891.

———. "A Trip After Bear in the Missouri Brakes, Montana." *The Field*, no. 2,002, May 9, 1891.

———. "A Trip After Bear in the Missouri Brakes, Montana." *The Field*,, no. 2,003, May 16, 1891.

———. "A Trip After Bear in the Missouri Brakes, Montana." *The Field*, no. 2,005, May 30, 1891.

———. "The Wolf in Montana," *Land and Water,* June 1901.

Craighead, Charles, and Bonnie Kreps. *Arctic Dance: The Mardy Murie Story.* Portland: Graphic Arts Center Publishing, 2002.

Davis, Richard. *The English Rothschilds.* Chapel Hill: The University of North Carolina Press, 1983.

Degroot, Gerard. "The War That Remade the World." *Christian Science Monitor Weekly,* May 26, 2014.

DeLorme Mapping. *Montana Atlas and Gazatteer.* Freeport, ME: DeLorme Mapping, 1994.

DeVoto, Bernard. *The Journals of Lewis and Clark.* Boston: Houghton Mifflin Company, 1953.

Evelyn Cameron: Pictures from a Worthy Life. Produced by John Twiggs. Missoula, MT: KUFM/Montana PBS University of Montana, 2005, DVD.

Freedman, Russell. *Lincoln: A Photobiography.* New York: Clarion Books, 1987.

Hagara, Evelyn. *Vocal Secrets of the Ancients.* Los Angeles: DeVorss and Company, 1940.

Hager, Kristi. *Evelyn Cameron: Montana's Frontier Photographer.* Helena: Farcountry Press, 2007.

Hart, Jeff. *Montana Native Plants and Early Peoples.* Helena: Montana Historical Society Press, 1996.

Hyatt, H. Norman. *An Uncommon Journey: The History of Old Dawson County, Montana Territory — The Biography of Stephen Norton Van Blaricom.* Helena: Sweetgrass Books, 2009.

Lincoln, Mrs. D. A. *Mrs. Lincoln's Boston Cook Book: What to Do and What Not to Do in Cooking.* Boston: Roberts Brothers, 1890.

Lucey, Donna M. "Evelyn Cameron." *National Geographic Birdwatcher,* May/June 2002.

———. "Evelyn J. Cameron: Pioneer Photographer and Diarist." *Montana: The Magazine of Western History,* vol. 41, no. 3, Summer 1991.

———. *Photographing Montana 1894–1928: The Life and Work of Evelyn Cameron.* New York: Alfred A. Knopf, 1991.

Makepeace, Anne. *Edward S. Curtis: Coming to Light.* Washington: National Geographic, 2002.

Melcher, Mary. "'Women's Matters': Birth Control, Prenatal Care, and Childbirth in Rural Montana, 1910–1940." *Montana: The Magazine of Western History,* vol. 41, no. 2, Spring 1991.

"Mme. Giulia Valda." *Frank Leslie's Illustrated Newspaper*, November 13, 1886.

"Mrs. Evelyn Cameron, Pioneer of Eastern Montana, Passed Away in Hospital at Glendive." *The Terry Tribune*, January 4, 1929.

Myers, Rex C., ed. "To the Dear Ones at Home: Elizabeth Fisk's Missouri River Trip, 1867." *Montana: The Magazine of Western History*, vol. 32, no. 3, September 1982.

Naglin, Nancy. "A Montana Album." *Americana*, February 1991.

National Geographic Society. *Field Guide to Birds of North America*. Washington, D.C., 1987.

Pagnamenta, Peter. *Prairie Fever: British Aristocrats in the American West 1830–1890*. New York and London: W. W. Norton and Company, 2012.

Patent, Dorothy Hinshaw. *Charles Darwin: The Life of a Revolutionary Thinker*. New York: Holiday House, 2001.

Posewitz, Jim. *Beyond Fair Chase: The Ethic and Tradition of Hunting*. Helena and Billings: Falcon Publishing Company, 1994.

Rattenbury, Richard C. *Hunting the American West: The Pursuit of Big Game for Life, Profit, and Sport, 1800–1900*. Missoula: Boone and Crockett Club, 2008.

Reich, Susanna. *Clara Schumann: Piano Virtuoso*. New York: Clarion Books, 1999.

Roberts, Ann, and Christine Wordsworth. "Divas, Divorce, and Disclosure: Hidden Narratives in the Diaries of Evelyn Cameron." *Montana: The Magazine of Western History*, vol. 64, no. 2, Summer 2014.

Rogers, Katherine M. *The Troublesome Helpmate: A History of Misogyny in Literature*. Seattle and London: University of Washington Press, 1966.

Rosen, Marvin J. *Introduction to Photography: A Self-directing Approach*. Boston: Houghton Mifflin Company, 1976.

Scholl, Jane D. "An extraordinary look at the frontier that's long gone." *Smithsonian*, November 1990.

Szasz, Ferenc Morton. "Scots in the North American West." *Montana: The Magazine of Western History*, vol. 51, no. 1, Spring 2001.

Tinling, Marion. *Sacagawea's Son: The Life of Jean Baptiste Charbonneau*. Missoula: Mountain Press Publishing Company, 2001.

Toole, K. Ross. *Montana: An Uncommon Land*. Norman: University of Oklahoma Press, 1959.

Toole, K. Ross. *Twentieth-Century Montana: A State of Extremes*. Norman: University of Oklahoma Press, 1959.

Vichorek, Daniel N. *Montana Farm and Ranch Life*. Helena: Montana Magazine/American & World Geographic Publishing, 1992.

Warren, Lynne. "Sublime Scottish Islands." *National Geographic*, vol. 217, no. 1, January 2010.

Wise, Michael. "Killing Montana's Wolves: Stockgrowers, Bounty Bills, and the Uncertain Distinction between Predators and Producers." *Montana: The Magazine of Western History*, vol. 63, no. 4, Winter 2013.

"A Woman's Big Game Hunting: Mrs. Evelyn Cameron Tells of Her Life in Montana." *The Sun (New York)*, November 4, 1900.

Zim, Herbert S., and Donald F. Hoffmeister. *Mammals: A Guide to Familiar American Species*. New York: Golden Press, 1987.

"The Zoological Society: Our Grizzly Bears." *The Field*, vol. 124, September 19, 1914.

INDEX

Page numbers in bold indicate photographs

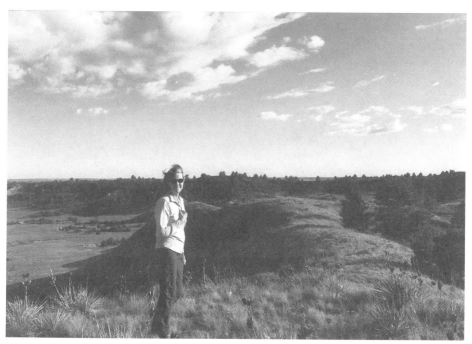

Lorna Milne stands above the second Eve Ranch on the north side of the Yellowstone River. Evelyn found agates and rattlesnakes on this hillside.

Lorna Milne writes from Helena, Montana, where she lives on a small farm with her husband and a soccer-playing, fowl-herding sheep dog named Little Bear. Milne has published essays and short stories in periodicals such as *Frontiers: A Journal of Women Studies, The Boston Globe Magazine, The Gettysburg Review, Walking, Orion, Highlights for Children,* and *The Sun.* She is a University of Montana journalism graduate who teaches writing and literature at Carroll College. Milne grew up in eastern Montana, near the Camerons' homesteads. This is her first biography.